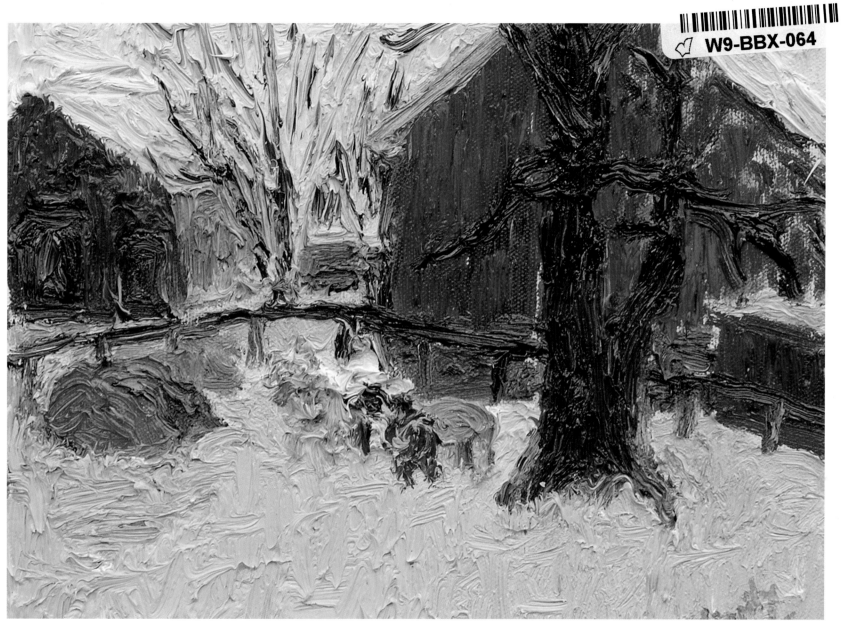

"A Deep Cold Winter" 8" x 10" oil on canvas, 2005

FARMS NEVER TO BE FORGOTTEN

A GLIMPSE INTO THE CHANGING PASTORAL LANDSCAPE OF HOWARD COUNTY, MARYLAND

PAINTINGS, PROSE & POETRY BY SHYAMI CODIPPILY

PAINTINGS PHOTOGRAPHED BY ROGER MILLER, FOREWORD BY GAIL BATES

"Dawn On The Bandel Farm" 16" x 20" oil on canvas, 2005

PAINTINGS BY **SHYAMI CODIPPILY**

POETRY AND WRITING BY **SHYAMI CODIPPILY**

FOREWORD BY **GAIL BATES**

EDITING BY **LINDA FOSTER AND DONNA VAUGHAN**

PHOTOGRAPHY OF PAINTINGS BY **ROGER MILLER**

INFORMATION

LIBRARY OF CONGRESS CONTROL NUMBER: 2005930820

ISBN # 0-911897-59-3

PRINTED IN CHINA

ORDERS

For direct orders please call or write for specific pricing and postage and handling to Shyami Codippily. Discounts are available for stores, institutions and corporations. The suggested retail price of the book is US$ 16.95.

SHYAMI CODIPPILY
3272 ROSEMARY LANE
WEST FRIENDSHIP, MD 21794
410-489-2875
WWW.SHYAMI.COM

IMAGE PUBLISHING, LTD
1411 HOLLINS STREET
BALTIMORE, MD 21223
410-566-1222
WWW.ROGERMILLERPHOTO.COM

ACKNOWLEDGEMENTS

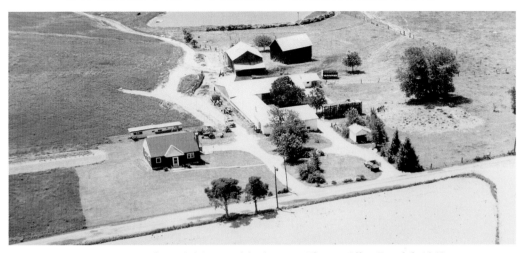

Aerial view of Bandel (Veri-Aldon) Farm; Photo: Allan Bandel, 1960
Triadelphia Road from the left corner to Rosemary Lane on the right. House and barns in
center, pond in back. The farm as it exists today can be seen on previous page

I sincerely wish to thank all those who helped me to produce this book.

My husband Scott, my son Taylor, my parents and in-laws - they provided much love, encouragement and support.

My neighbors Gail Bates, Ellen Nibali, Stephanie Olson, Brian and Haydee Morrison and Lisa Peklo - who shared much information.

My Publisher and Photographer Roger Miller, his Marketing Director Linda Foster, and Image Publishing, LTD.

My editors Donna Vaughan and Linda Foster; my Agricultural Advisors Dr. Allan Bandel and Caragh Fitzgerald for their criticism.

My Art Teacher, Walter Bartman, who taught me how to see a landscape and my Music Teacher, Virginia Manchester, who taught me how to listen to a landscape.

Sharon Russell and Connie Surosky of the University of Maryland CMREC, Madeleine Greene and Caragh Fitzgerald of Maryland Cooperative Extension, and Ginger Myers of Howard County Economic Development Authority, for their encouragement.

My advertisers, who are part of the community, and provide excellent services in their own fields.

Allan Bandel, Peggy Howell, Gerald Cooney, Sharon Russell, The Univ. of MD, James Ferguson & John Frank for their photographs.

Most of all, I wish to thank the farming community in Howard County for the beautiful pastoral landscape and rich bounty it has to offer. The farmers not only work this land and pioneer various enterprises within the county, but they also foster the well-being within the community. They have provided a wealth of information and inspiration, and it is my good fortune that I live close to them.

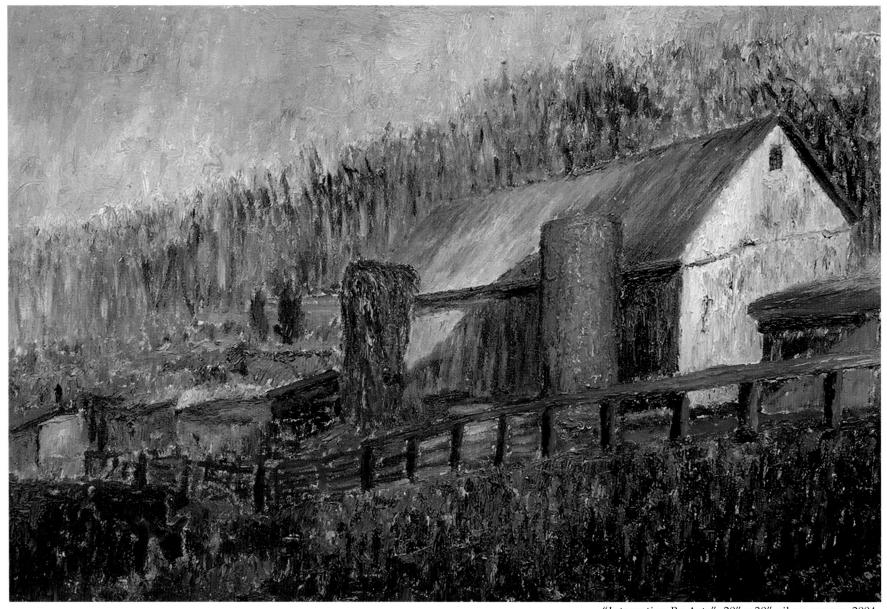

"Integration By Arts" 20" x 30" oil on canvas, 2004

CONTENTS

Roberts Inn, Cooksville, MD, 2005

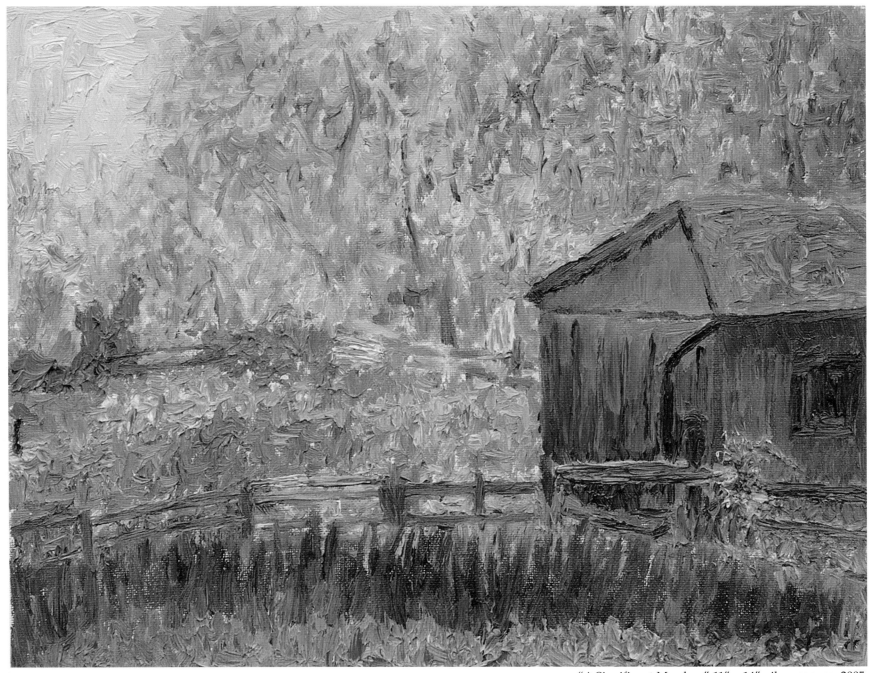

"A Significant Meadow" 11" x 14" oil on canvas, 2005

FOREWORD

 Howard County's gently rolling hills, moderate climate and rich soil provided the ideal location for some of the finest and most productive farms in Maryland. It is this wonderful heritage that wooed many of us to Howard County, first to visit, then to live. Coupled with an excellent school system and proximity to both Baltimore and Washington, Howard County has become the prime location for living and raising a family. Due to the strong demand for housing, land that was once dedicated to raising corn, wheat, and cattle is now raising houses.

 *Shyami Codippily's beautiful paintings keep alive our memories of vistas that are slowly slipping away. The images she provides and the stories about the farms, will be treasured by both natives and newcomers to this beautiful land that forms the heart of Maryland. Thanks to Shyami's brilliant landscapes, these historic **farms will never be forgotten.***

Gail Bates
Thirty Year Resident of West Friendship, MD

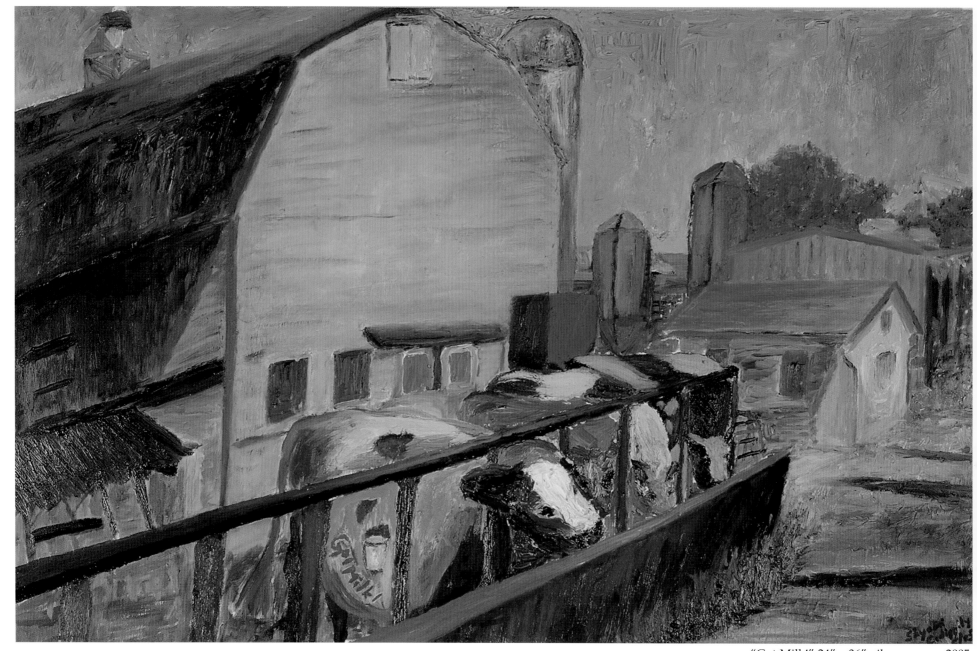

"Got Milk!" 24" x 36" oil on canvas, 2005

NOT JUST COWS AND PLOWS

In the late 1770s, John, Andrew and Joseph Ellicott persuaded local farmers to revitalize their soil by using plaster as a fertilizer and then planting wheat instead of tobacco. As a result, the Ellicotts gained a local supply of wheat for their new flour mill. By this time, tobacco was beginning to be produced more profitably in the Virginias, and farmers in the Patuxent Watershed profited by growing a new alternative cash-crop. Over two hundred years later, Howard County farmers are still being challenged to change their cropping methods, to grow alternative crops to the traditional Maryland triumvirate of corn, hay and small grains, and to vigorously seek out new markets for their goods and services.

Twenty years ago, Howard County government recognized the need to preserve adequate farmland in a region that was ripe for development. Howard County launched one of the earliest Farmland Preservation Programs in Maryland. Today, almost 20,000 acres of farmland have been preserved for agricultural use in the county. It is not enough to just preserve the farmland; we must also preserve the farmer. Opportunities must exist for the farmer and for future farming generations to operate both profitable and sustainable agricultural enterprises. Howard County agriculture is in transition. There will still be traditional agriculture here, but depressed international commodity prices, the shortage of affordable labor, and increasing governmental regulations have forced even the most ardent "cow and plow" farmers to look for alternative crops and other uses for their on-farm resources.

Diversity in Howard County's agricultural community began in the sixties. Today, nurseries, horticulture, and turf production comprise the largest segment of agriculture in the county. The horse industry is mushrooming here. Agriculture here is expanding to include vegetables, fruits, herbs, specialty meats, organics, pick-your-own operations, Christmas trees, and agri-tourism. Areas for further expansion include farming pharmaceuticals, small animal production, eco-tourism, value-added farm products, organic livestock grain, and a myriad of specialty vegetables. While challenging, there are also some unique advantages to farming in Howard County. Located at the center of the fourth largest metropolitan area in the country, local producers have access to a consumer base and transportation network that other farming communities can only envy. There is a strong commitment to help the agricultural community not only survive, but prosper here. This support comes from the County Government, the Howard County Economic Development Authority, the Maryland Cooperative Extension Service, and the Maryland Department of Agriculture.

What is the future for farming in Howard County? That will depend on how farmers react to the region's changing markets for products and services. Most will need to tailor their operations to include some type of alternative agricultural enterprises. There will be change, but change has been happening to Howard County agriculture ever since those early farmers planted the first wheat fields in the late 1770s.

Ginger S. Myers
Agricultural Marketing Specialist
Howard County Economic Development Authority

INTRODUCTION

As a landscape painter, I chose to depict in oil the farms of Western Howard County, Maryland as my next "New" project. Little did I realize that I would be inspired by the "Old." Although many of the farms are operating in sound condition, I found more appeal in the rustic barns and silos, and the weathered farmhouses and fences. As a resident of this part of the county, over the years I began to notice that every few months an old farm was sold and developed into new homes. The growth of new housing is always a good indicator of a booming economy, and politics aside, the uses of land change with the needs of the population. Having realized this, I felt the need to capture on canvas what is left of an era when farming was big in this part of the county. I felt the need to learn about the people who owned and worked the land - be it a Researcher looking for better growing methods, an Educator who cultivated his students as well as his crops, a Senator who is a Fiscal Conservative, a Lady who prides in knowing that shot embedded in her Inn was from the Civil War, or a Friar who prays on the grounds of one who founded this country. These folks and their farms should never be forgotten.

The farms included in this book are located to the West of Route 29, which travels North - South through Howard County. Most of the farms are within 5 miles of Route 144, known as "The Road West," and "The Historic National Pike." Major roads from Route 29 are Routes 40, 108, 216, 32, 99, and 70 - the major highway. I randomly chose which farms to paint and include in this book. Although there is some history included with each farm, I produced this book through my eyes as a landscape painter, and not as a historian. Joetta Cramm and Barbara Feaga are the experts on Howard County's history.

There are thirty oil paintings in this book, and the canvases are of various sizes. Each painting includes a bit of history, some life-experiences of the farm owners, and a little lesson in art. Since artistic interpretation is usually subjective, I have included some of my theories and intentions, which might help both the critic and novice understand my work. As a student, I studied Art History - the life and times of artists and their interpretations of the changing world around them. As an artist I felt the need to explore the stories behind the ears of corn, the flocks of sheep, and the cattle that approached me with curious eyes, as if to say, "Hey lady, I'll pose for you any day. How do you like my grin? Would you like my left cheek bone or right ear? I've got a great looking hind-leg, too!"

On a personal note, I hope this work will enable my son Taylor to recall how the county looked while he was growing up.

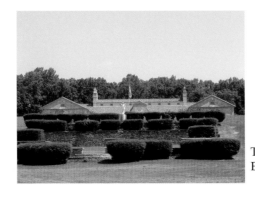

The Franciscan Friary
Ellicott City, MD

A NOTE ON MODERN DAY ECONOMICS

John Locke, a 17th century English philosopher and radical thinker of his time, believed that "God gave the earth to all men in common, and that we are supposed to make use of the earth for the best advantage of life and convenience." Many economic principles are based on his ideals and theories. Much of our present-day economy is based on capitalistic principles, and growth is the result of replacing old methods with new.

According to United States Budget Statistics, net farm income for 1945 was 12.3 billion dollars, and it increased steadily (with only a few recessive dips in 1959, 1964, & 1983) to 55.8 billion dollars by 2003. However, a gradual decline in the farming industry can be seen at the state and county levels. The State of Maryland had approximately 12,700 farms in 1992 and had approximately 12,200 farms in 2002. Howard County had 382 farms in 1992, and 346 farms in 2002. Howard County farmland has decreased from 44,623 acres in 1992 to 37,582 acres in 2002 (almost a 16% decline in 10 years). A similar decline can also be seen in the production of crops and livestock (37% decline in dairy cows).

Urban sprawl and the decline of traditional farming have been studied worldwide. One factor for this decline is that being close to the high-tech industries along the eastern seaboard, the population has demanded more housing within commuting distance of over-crowded cities such as Washington, D.C. and Baltimore. The population in Howard County in the year 2000 was 250,720 people. By the year 2020, this is projected to be 303,500. For the crop and livestock farmer of a marginal-profit making operation, the appeal to sell his land to a developer for instant gain is attractive. Another factor is that even though the technology to increase production is readily available, the labor is not. For example, families now have only 1-2 children, as opposed to 4-5 during previous generations, and hence, fewer hands to milk the cows. A farmer's children may find higher salaries in the fields of business and technology as opposed to the bovine fields. Manual labor on a farm has few incentives. One farm manager candidly said, "I don't know why I travel from the Eastern Shore to work in this hell-hole!" I replied (having recently left my "desk" job), "the grass is never greener on any side of the fence!" A third factor that has contributed to farming decline is politics. The building of roads and the sacrifices made for easements, the importing of goods from overseas, taxes and regulations - all affect a farming community.

Many farmers have been successful in adapting to changes by using their land for viable enterprises. Some farms have converted to sod and horticulture to meet the landscaping needs of housing and business complexes. Others have developed into horse farms, agri-tourist farms and grain and produce farms. As an artist, my goal is to preserve visually the present day of my community, for generations to come!

Howard County Statistics:	1969	1992	2002
Number of Farms	445	382	346
Land in Farms	75,843 acres	44,623 acres	37,582 acres
Crop land harvested	30,238 acres	26,256 acres	20,621 acres
Corn for grain	10,413 acres	10,679 acres	7,162 acres
Wheat for grain	1,982 acres	2,286 acres	1,942 acres
# of Milk cows	3,860	1,429	897
# of Beef cows	15,200	2,019	1,359
# of Hogs & Pigs	4,367	3,771	263
# of Sheep & Lambs	1,291	1,081	780

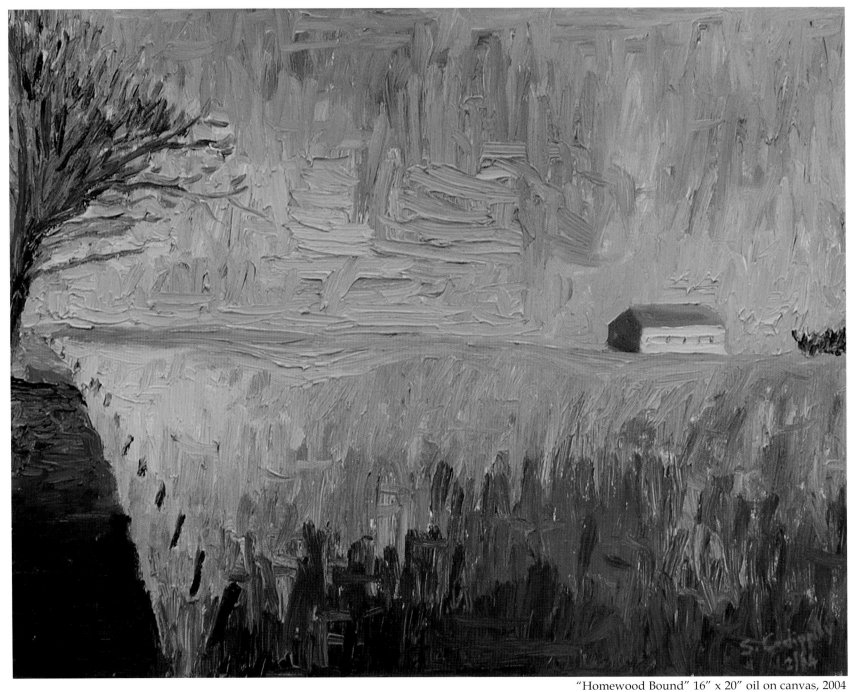

"Homewood Bound" 16" x 20" oil on canvas, 2004

12

"Homewood Bound"

The crisp blue sky of a February afternoon
Brought me out of my deep cold winter's gloom
The budding tree, solitary barn and thawing ground
I could see for miles as I was Homewood bound.

For many years I have traveled along Homewood Road, as a method of avoiding the major highways, to reach my destinations. As I came around the turn each time, I would pass this solitary barn on top of the hill. I would often wonder about that lonely barn. Who did it belong to? Who or what lived there?

As I began this book, I discovered that the home of a young female cow is called a heifer shed. This was the home of young Buttercup, Bessie, and Blush. This was where these young cows grew up to be milk producers for the benefit of the farming community, the county, and the State of Maryland.

The heifer shed depicted in "Homewood Bound" is part of a 920+ acre facility belonging to the University of Maryland's Central Maryland Research and Education Center (CMREC).

There is much history and activity within these rolling pastures. This facility houses offices of the Maryland Cooperative Extension, which is the University of Maryland's outreach program. Included are regional and state offices for the Cooperative Extension in areas of nursery, greenhouses, and horticulture management; 4-H youth development; and environmental management.

The facility is also a site for research. The center's research projects include dairy production, grain trials, wetlands restoration, and pest management. The students and researchers at the Clarksville site have the advantage of hands-on learning from "the ground up!"

From the ground and up is usually what Landscape Painting is about. Composition - the placement of a subject on a surface, can be as varied as the size and shape of all creatures great and small.

This particular composition is unique because of the convergence of the vertical line of the tree, the horizontal line of the grass, and the diagonal line of the edge of the road.

The simple shapes give the painting balance and harmony. The principles of color and light are of utmost importance in creating spatial relationships; warm tones define foreground space, cool tones define background space.

Including one's ideas, energies, and experiences into a painting distinguishes one artist's style from another. For me, during the creative process, these elements are one and whole.

I will never forget the pure blue sky watching over the trees, the ground, and Bessie's home, the heifer shed.

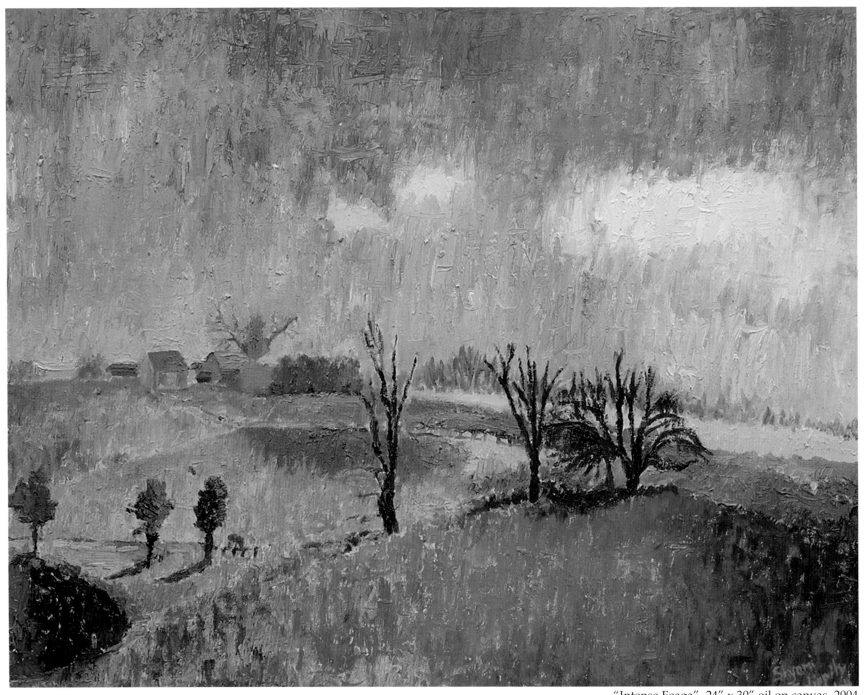

"Intense Feaga" 24" x 30" oil on canvas, 2004

14

"Intense Feaga"

Old barns on Merry Acres Farm, 2005

Today's Howard County farm owners remember when most of their community was a farming community. Due to economic changes within the county, Sod and Horticulture Farming and Horse-Recreational Farming are popular types of farming that have replaced traditional Dairy Farming. Growth in the housing industry has created the need for bright green lawns and professionally landscaped front yards. Likewise, the population has more time and money for recreational pastimes such as horseback riding.

In 1958, Bernard and Edna Feaga purchased the 101-acre property they had been renting on Triadelphia Road known as Merry Acres Farm. Merry Acres had been a successful dairy farm while expanding and modernizing its milking operation throughout the years. Until the mid-1950s, milk was shipped to a commercial dairy in Baltimore in heavy 10-gallon milk cans. This changed in the mid-late 1950s when a modern stainless steel pipeline was installed in the barn that allowed milk to flow directly from the cows in the barn to a large bulk milk tank cooler in the attached dairy building.

Each of Bernard and Edna's five children helped with the work. The eldest son, Howie, now owns and manages the farm which is protected under Farmland Preservation. In the late 1990s the farm began to board horses, serving the demand for recreation. There is still a small Angus beef herd, and a few Holstein heifers (female cows). The crops still grown include hay, corn, and wheat. Howie, who grew up on this farm, is a keen observer of weather conditions and fertilizer cost-factors that influence the growing process.

The growing warmth of the fertile ground is the inspiration for "Intense Feaga." I attempt to depict in my paintings the three-dimensional qualities of my subject matter. Red, known for its advancing property, creates the volume of the small hills in the foreground. Decreasing intensities of reds are used to depict the smaller and more distant hills in the middle and background. Blue, known for its receding property, defines the pond. Each primary color is intensified by its opposite color: red by green, blue by orange, and yellow by purple. I drive by Merry Acres Farm frequently, and each Spring, the ground is covered with increasingly more grass, foliage, and buttercups.

Horse ring on Merry Acres Farm, 2005

I will never forget the meandering horses, rippling pond, and buttercup ground of Merry Acres Farm.

15

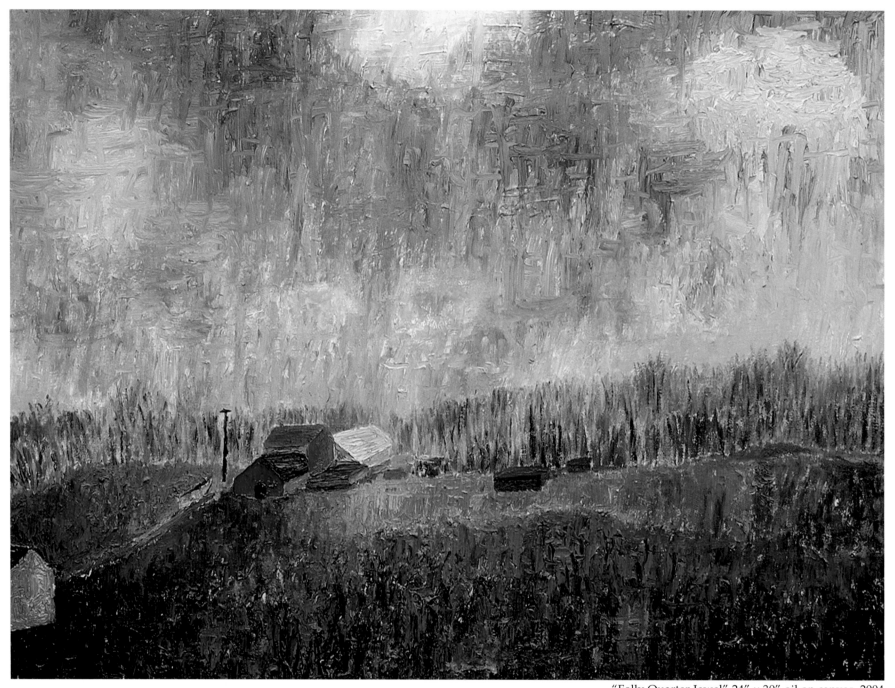

"Folly Quarter Jewel" 24" x 30" oil on canvas, 2004

"Folly Quarter Jewel"

A Jewel is a treasure to have and to hold
Be it a friendship, a work of art, a piece of gold
It could be a tale from the past, a body of water
Or the fertile ground that borders Folly Quarter.

A jewel can be found along the road, you may pass by at incredible speed, until one day you stop to learn its tale. The tale of "Folly Quarter" is that it was the name of the Southwestern quadrant of Doughoregan Manor Estate owned by Charles Carroll, a signer of the Declaration of Independence. The estate was used for recreation (folly), and the manor was built for Carroll's granddaughter, Emily Caton McTavish.

Since 1928, the manor and property have been home to the Franciscan Friary. In July 2004, the Friary was decreed the "Shrine of St. Anthony" by Cardinal Keeler, Archbishop of Baltimore. The Friary houses a significant relic of St. Anthony from the Friars of Padua, Italy. The Friary's marble buildings are perched on 236 acres of rolling hills, and are designed after the "Sacro Convento" of Assissi, Italy - the burial home of St. Francis.

Father Donald, Interim Director of the Friary, finds the grounds a wonderfully peaceful place. He says that visitors find it a place to relax, pray, and decompress. The Friary conducts retreats, masses, and prayers for healing. Photo of the Friary can be seen on the "Introduction" page.

On the same corner of the Friary, there are 920+ acres of farmland, which now belongs to the University of Maryland's Central Maryland Research & Education Center - Clarksville Facility. This historic property was part of an original land grant made to the Carroll Family by the King of England.

The scientists at this facility conduct research on how to improve various grains and forages such as corn, wheat, alfalfa and soybeans. The barns shelter a large dairy herd used for both milk production and dairy research. Most of the crop production begins in the Spring, and ends in the Fall, but the research continues year-round.

The growth of each kind of grain is dependent on the correct amount of rainfall, sun, and soil quality. The farmers are well versed in controlling certain conditions, but mother nature usually dictates the difference between an average yield and a spectacular yield. The researchers work tirelessly to culminate data for ideal production.

"Folly Quarter Jewel," as in most of my work, is a culmination of all the senses. This landscape, especially, has the visual sense of afternoon light; the smell of the horse farm across the road; the tactility of weathered structures; the sound of the soft wind in the trees; and the taste of the fertile ground in which the year's corn is about to be sown.

If you find this too poetic, try standing on Folly Quarter Road, and you will learn the reasons why this farm is indeed a jewel!

I will never forget that I have driven along Folly Quarter and only now know from where its name came.

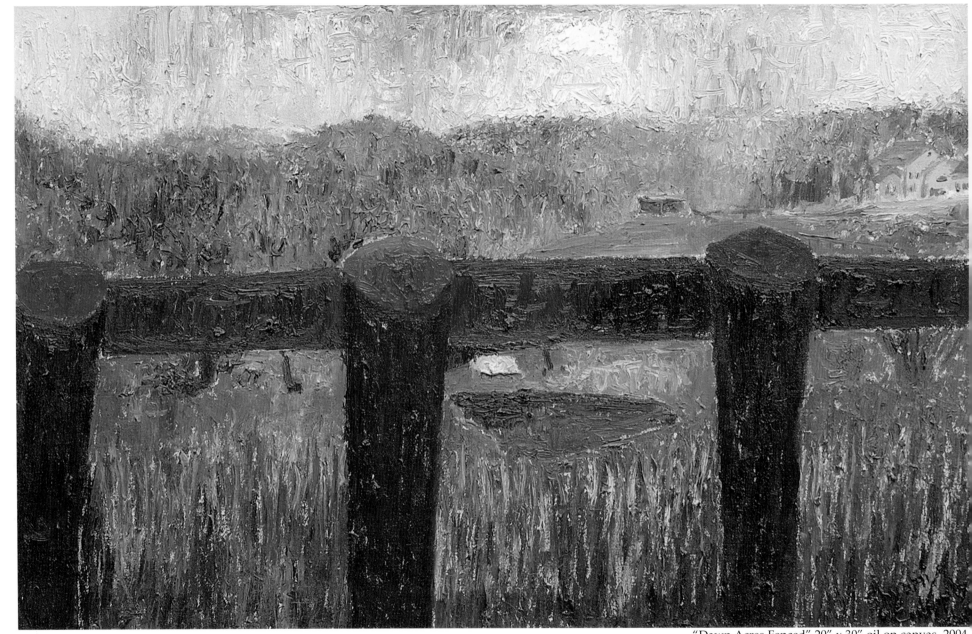

"Dawn Acres Fenced" 20" x 30" oil on canvas, 2004

18

"Dawn Acres Fenced"

Barns on Dawn Acres Farm, 2005

From its origin around the late 1700s until recent times, Route 144, the Historic National Pike, was the most traveled road from Baltimore through Ellicott City, West Friendship, Lisbon, and Mt. Airy. It extended all the way into Cumberland, MD. This road connected the farming community in rural Howard County with the industrial communities of Ellicott City and Baltimore. Now that the population has outgrown the communities in Eastern Howard County, the housing movement is growing rapidly into the Western region of Howard County.

Dawn Acres is located along Route 144 in West Friendship, across from the Howard County Fairgrounds. The original home, a historic site, was built in the 1760s by Adam Barnes. The Moxleys arrived from England in the 1700s and settled in Montgomery County, MD. In 1917, Mr. James Moxley, Sr. purchased this 204-acre farm that includes two ponds. Dawn Acres is now owned and operated by his son, Mr. James Moxley, Jr. and his family. Around 2001, Mr. Moxley Jr. purchased an additional 200 acres from a neighboring farm.

Mr. James Moxley, Sr.'s brother, Mr. Edgar Russell Moxley (now deceased,) served as Howard County's first Police Chief. The Moxleys have always raised Angus Cattle. They also have horses for recreational purposes. This lush property is protected under Farmland Preservation.

"Dawn Acres Fenced" is titled simply for it composition. The painting was composed from across the street, and it happened that the fence around the farm was in my view. From a landowner's point of view, the fence binds and protects the property. From an artist's point of view, the fence unifies the painting's individual compositions.

Dutch painter Piet Mondrian was a master at compositions within compositions. The composition above the fence includes the sky, trees and house. The center includes the pond, and grass. The remaining sides include mostly grass. Although each segment could be viewed separately, the fence unifies the entire space.

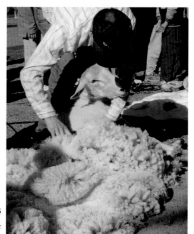

Sheep & Wool Festival at the Fairgrounds
Photo: Peggy Howell, 2004

I will never forget the wide, open spaces of Dawn Acres bathed in blazing afternoon sun.

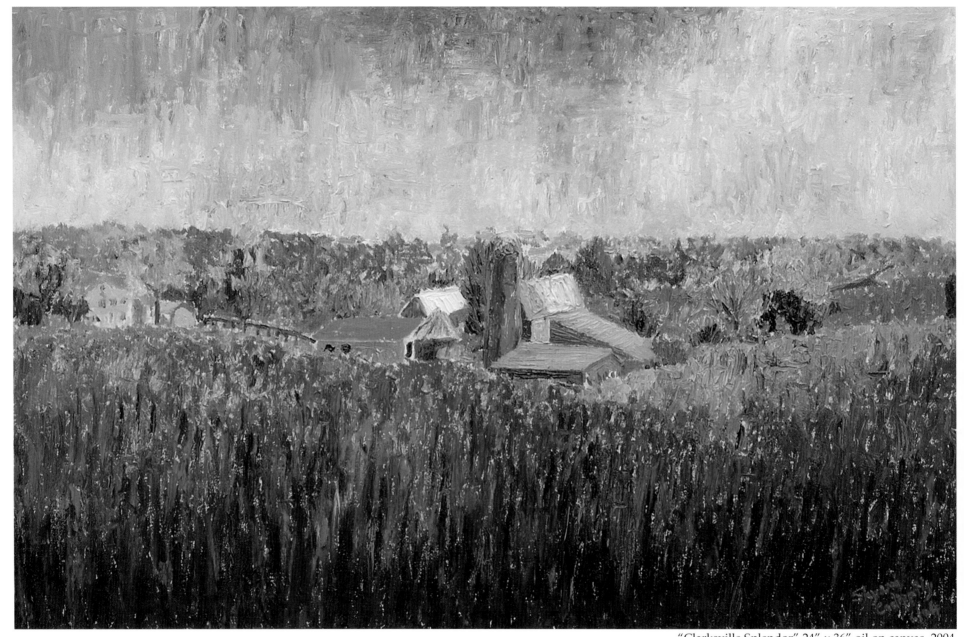

"Clarksville Splendor" 24" x 36" oil on canvas, 2004

20

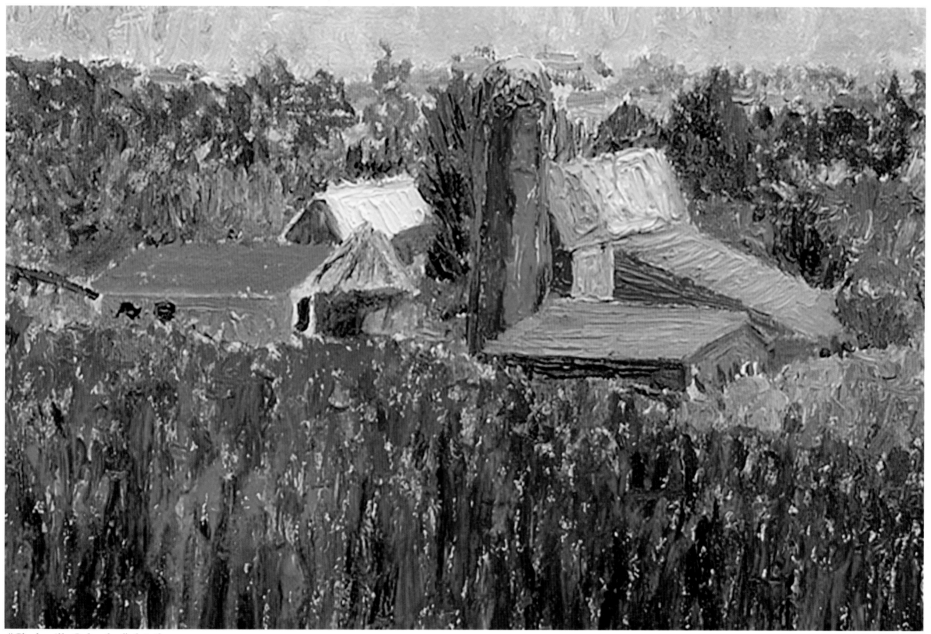

"Clarksville Splendor" detail

"Clarksville Splendor"

> *What's in the meaning of a color such as red?*
> *Use it to express love and battle, virility and dead*
> *Or a glorious farm that has weighed its strife*
> *To rid the old and on fertile ground bring new life!*

Over the years, communities have developed from the homestead to the township to the city - all the result of new life. Clarksville was first established in the early 1800s by three brothers, James, John, and David Clark, who emigrated from Ireland. At the time, Clarksville was known as the "Paris of the 5th District," since many politicians mingled here. The Smith Farm, along Route 108, is one of the last farms in Clarksville. Most of Clarksville now consists of businesses, a shopping center, an auto park, mansions, glamorous single homes and condominiums. Although new homes are an indicator of a healthy economy, for the farming community this is the end of their "heyday."

A few months after painting "Clarksville Splendor," I went on a quest to the Smith Farm. I walked up the weedy pathway leading to the farmhouse. I saw a tractor and some other old equipment in rustic sheds. I saw a solitary cat grooming itself in the sun. I knocked on the door. No one answered. I was about to leave when something caught my eye - the names "Max and Elizabeth Smith" were engraved in the brass door-knocker. I was now determined to find a way to learn more about the lives and times of Max and Elizabeth Smith!

After many visits to the property, I managed to meet with the Smith's nephew, Mr. Gerald Cooney, who lives on the property with his wife. Mr. Cooney took me back to 1898 when the farm was over 160 acres, and was owned by the Richardson brothers. In 1898 the brothers petitioned the circuit court to divide the farm in to two equal shares. John Cooney and his wife purchased the 80+ acres that borders Route 108. After Mr. Cooney's death in 1943, his daughter Elizabeth and her husband, Max Smith, purchased the farm from the elderly Mrs. Cooney. The Smiths had no children of their own, but they raised their nephew Gerald Cooney on the property.

Max and Elizabeth Smith grew corn and wheat and raised cattle on their farm. In addition to farm work, each had a successful career. Mr. Max Smith worked for the Board of Education for 46 years. He served as the first Principal of Glenelg High School, and as the Principal of Clarksville Middle School and both Clarksville High Schools. He was instrumental in establishing Howard County's first Vocational Technical Center, now known as the Applications & Research Laboratory, located next to the Board of Education.

Applications & Research
Laboratory, 2005

A newspaper article described Mr. Smith as truly caring for the students he taught, but at the same time, innovative in discipline methods. Once when he had a visitor of high rank in his office, it started to rain flowerpots from the third floor window. The mischief-making boys in question spent the next few weeks potting flowers for Mr. Smith. Elizabeth Smith worked for the Central Bank of Howard County, which is now Citizen's National Bank. Max passed on in August 1999, and Elizabeth in February 2002. Although the farm was sold in 2002 (and Clarksville will see many new homes on this land), Gerald Cooney continues to live in the home he built on a corner of the farm. Mr. Cooney will always remember his childhood here, and has no plans to live anywhere else.

Most of us strive to fulfill our childhood dreams. I can recall at the age of three receiving a box of paints at a neighborhood Christmas party. When I got home, I splattered an entire tube of blue paint all over myself and my party dress. The splattering still continues, but the party dress comes off before I start painting.

Clothed in painting attire, I stood on the side of Route 108 as I painted "Clarksville Splendor." This early summer painting encompasses all that comes to me during the process. The strong reds juxtaposed with the greens create vibrancy. The touches of reds and greens in diminishing quantities and shades create depth. The background composition is dotted with numerous homes in the township of Riverhill. The middle-ground composition is balanced with the farmhouse on the left, the fallen tree-trunk on the right, and the silo and structures in the center. On a symbolic level, the composition shows a silo erupting from the fertile earth, and rightfully so, since Clarksville was once a productive farming town.

Max & Elizabeth Smith, mid-1980s
Photo: The Cooney Family

I will never forget the haunting presence of Max and Elizabeth Smith as I strolled in their seeded ground.

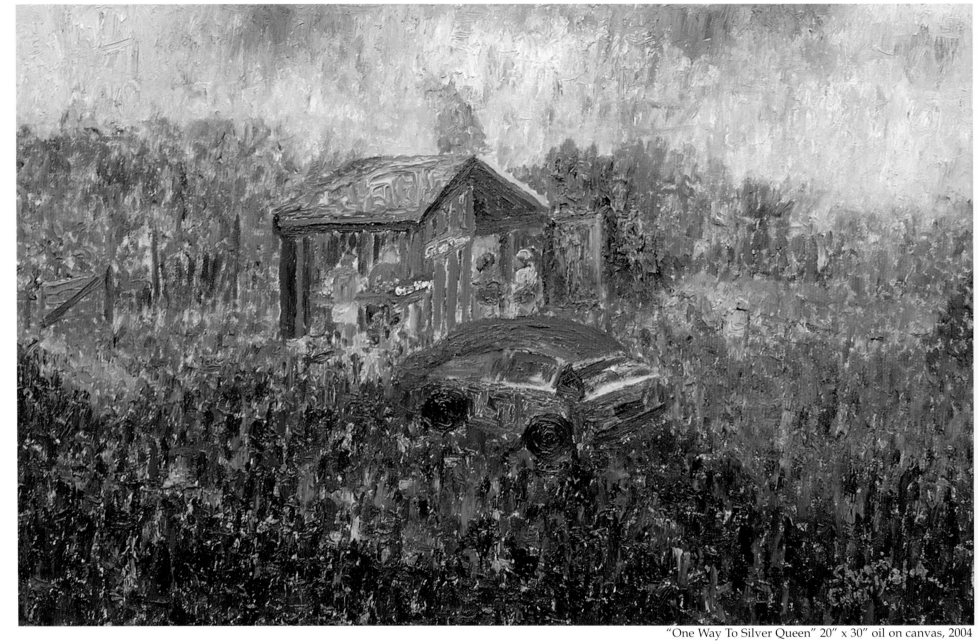

"One Way To Silver Queen" 20" x 30" oil on canvas, 2004

24

"One Way To Silver Queen"

Clark's fields, 2005

Route 108 is one of the busiest and most traveled roads in Howard County. It runs from East to West and then South into Montgomery County. Route 108 connects to major roads such as Routes 175, 100, 29, 32 and 216 in Howard County. What would a little vegetable stand be doing in this world of speed? Well, this vegetable stand brings many a summer traveler to a halt, since it sells the freshest Silver Queen corn.

This traffic-stopping stand belongs to Clarkland Farms, which was established in 1797. It is home to the 5th, 6th, and 7th generations of Clarks - direct descendants of John Clark, one of the original brothers from Ireland that founded Clarksville. Clarkland Farms produces corn, potatoes, melons, tomatoes, peppers and winter wheat. The growing season begins in April and May, and the fresh produce first appears in July. The farm is over 500 acres, stretching West and North from Centennial Lane along Route 108. Since the farm is protected under Farmland Preservation, Clarkland Farms will continue to produce a colorful bounty for years to come.

Color - yes, color theory at its most efficient! The summer sun is reflected in "One Way To Silver Queen" by the bright orange roof and set off by the blue sky around it. Since black is known to absorb light, the asphalt is depicted by a multitude of dark colors all woven together with only flickers of reds and yellows that represent gravel. The car in the foreground, although white in reality, is painted a dull red since it occupies a foreground space and reflects the heat from the sun. Dull red, as opposed to bright red, is chosen so as not to compete with the bright orange roof - the hottest part of the vegetable stand, and the painting's focus. The composition simply describes the passer-by that parks her car in front of the stand to pick-up fresh produce. I painted this scene standing across the street, on the premises of The Iron Bridge Wine Co., my favorite place to dine year-round!

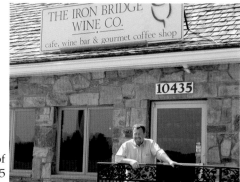

Steve Wecker, co-owner of The Iron Bridge Wine Co., 2005

I will never forget the hustle and bustle of shoppers around Clark's colorful homegrown fruits and vegetables.

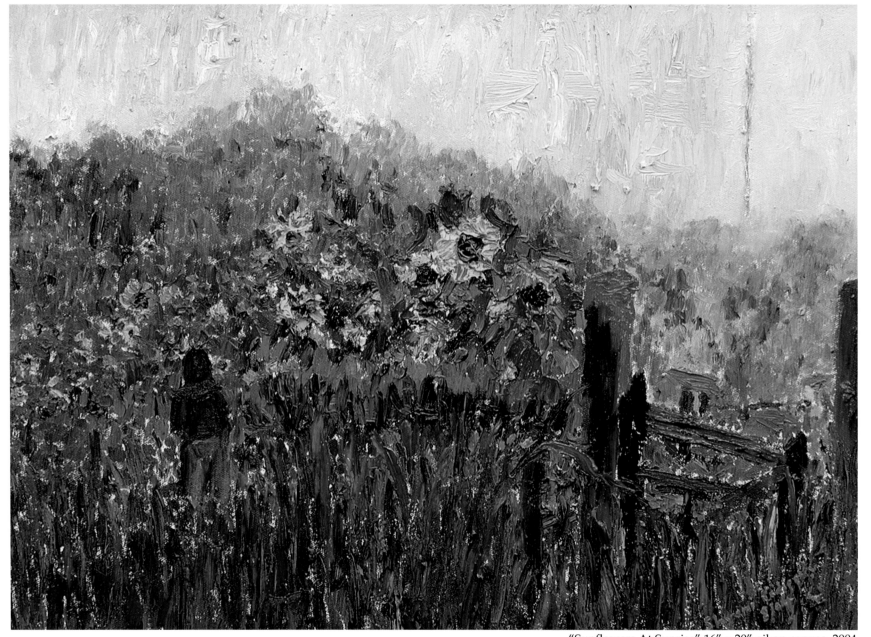

"Sunflowers At Sunrise" 16" x 20" oil on canvas, 2004

"Sunflowers At Sunrise"

Starry nights give birth to days of starry light
That grows the seeds and makes the earth bright
Sir Isaac had studied the Sun's energy and power
But Vincent pictured the many strokes of a sunflower.

Clarkland Farms boasts the most spectacular sunflowers in Western Howard County! Once again, the traffic speeds by on Route 108, but one nature-lover stops to photograph these splendid specimens in the light of the rising sun. Among the sunflowers, one can also find many colors of marigolds and zinnias. This picturesque farm is owned and operated by Senator James Clark and his family. Senator Clark believes that land is a natural resource that is meant to sustain us. Although the crops and livestock sustain the body, these sunflowers help sustain a lightness within a harried traveler.

Light and power - what our lives are dependent on mostly. Living in West Friendship, MD, I often find myself without either after a storm. Since I couldn't do much else one powerless August morning, I set out early to paint with the rising sun - the power that keeps these sunflowers and the rest of the world alight!

Sir Isaac Newton was one of the first physicists to study light and break it down into its colors using prisms. Newton was also one of the first to study pigments in soil and plant extracts. He "bubble-bubbled, toiled and troubled" late into the night with experiments that ultimately benefited paint manufacturers. As a present day artist, I find that using color in its purest form without much mixing, brings out the maximum vibrancy in a painting.

Another quality which enhances a painting's vibrancy is the main subject's surrounding atmosphere. In "Sunflowers At Sunrise," depicting the atmosphere (in less intense tones) was just as important to me as the sunflowers that are the main subject.

Painting atmospheric conditions was a favorite theme of the Impressionist painters during the late 1800s. Vincent van Gogh believed in capturing not only the physical qualities of his subject matter but also its surrounding atmosphere, as seen in many of his Sunflowers from the late 1800s.

In my painting, the diffused background tones of the morning mist powers the colors of the foreground sunflowers, foliage, and photographer.

I will never forget those big golden flowers smiling upon everyone within their sphere.

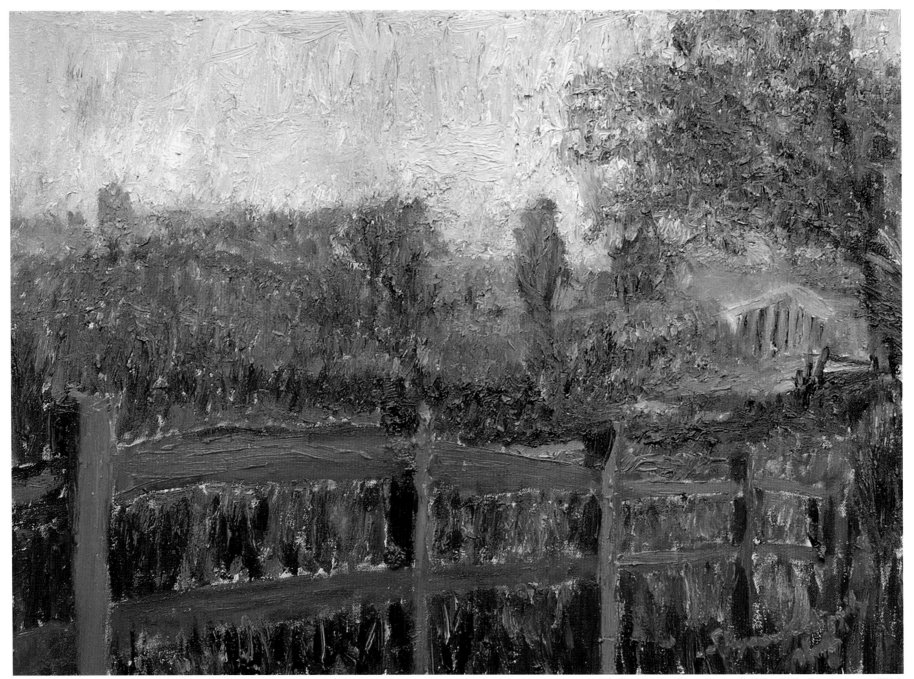

"Pathway To Silver Queen" 18" x 24" oil on canvas, 2004

"Pathway To Silver Queen"

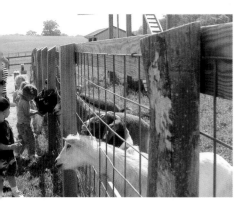

Kids petting goats on Clark's Elioak Farm, 2005

Clark's Elioak Farm is active from the Spring through the Fall. Clark's Elioak petting farm is an example of Agri-Tourism. In the Fall, school children arrive by busloads to pick their pumpkins, and pet the sheep, llama, goats, donkeys, rabbits, and other animals. The goats also produce milk that is the main ingredient in R.J. Caulder's hand-made soaps, which can be purchased in the farm store.

To me, it is nice to know that Howard County celebrates the farming industry with "Farm-City Days" for about ten days in September. Educational activities and demonstrations are conducted at farms throughout the county, and related displays are set up at libraries and other public places.

Martha Clark, Senator Clark's daughter, operates the petting farm, provides educational tours, and celebrates children's birthday parties on the farm. Martha's talents and capabilities exceed most modern-day women's comprehension. In addition to serving as a board member of the Howard County Tourism Council, Martha is a hands-on

kind of lady. If she is not managing her accounting books, she is organizing the farm store, or fixing benches. And when it comes to a birthday party, she is ready with her party-hat!

The middle of September gives birth to the changing light and russet colors of Autumn. The pathway leading to the vegetable stand of the bygone Summer was the inspiration for "Pathway To Silver Queen." The overcast sky determined the muted tones.

In order to create depth, the sienna depicting the fence is repeated in diminishing quantity from foreground to background, contrasting with shades of viridian. The composition works from left to right: from larger fence-posts on the left toward smaller on the right, and pathway from the left ending at the vegetable stand, the painting's focus. Decreasing sizes and paths that converge at a focal point are techniques that originated with Leonardo da Vinci during the Renaissance in Europe in the 1500s.

Handmade soaps by R.J. Caulder, 2005

I will never forget the "Down On The Farm" atmosphere of animals and children at Clark's Elioak petting farm.

29

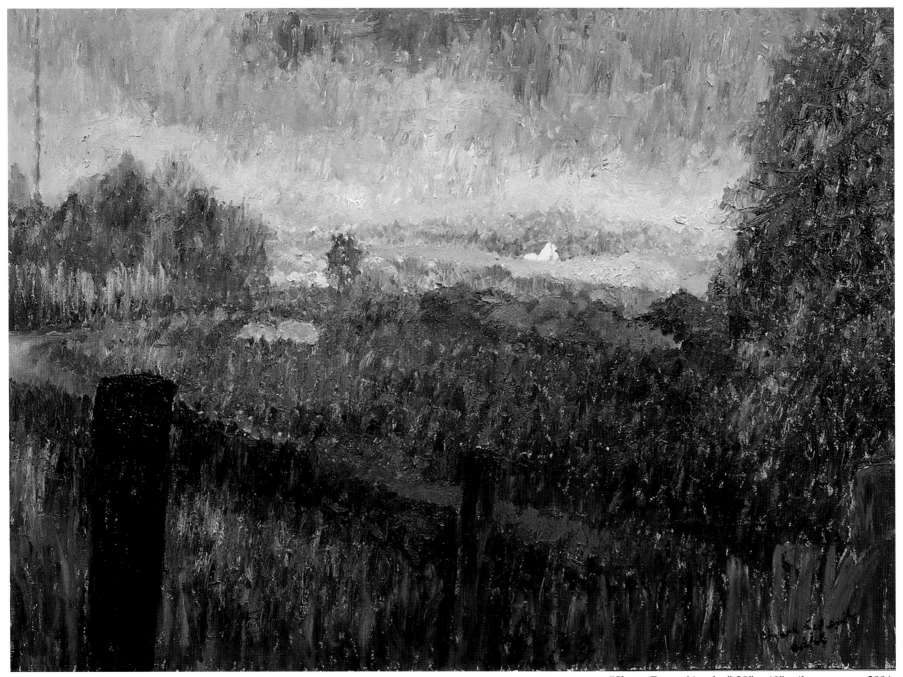

"Sheep Down Yonder" 30" x 40", oil on canvas, 2004

"Sheep Down Yonder"

> *Abe Lincoln and James Clark were men of politics*
> *Both loved their country, their people and pragmatics*
> *They spoke and wrote much which kept them from sleep*
> *But they are loved as guiding shepherds of their sheep.*

James Clark, Jr. a direct descendant of John Clark (originally from Ireland), was educated at Ellicott City High School and Iowa State University, where he earned his degree in Agriculture. When WWII broke out, he served as a combat glider pilot. He was elected to the House of Delegates in 1958, and served as a Maryland State Senator from 1962-1986. He is a Fiscal Conservative, a strong believer in Civil Rights, and a follower of the many conservative policies of Abraham Lincoln. At the lively age of 86, Senator Clark is warm, witty, and welcoming.

Since 1797, his family has been in the cattle business. Now, the farm also raises sheep for the sale of lambs and wool. Owning and operating a farm of any shape or size has its rewards and challenges. Clarkland farms, like many others, has had its share of barn fires - one in the 1930s, another in 2002, and the most recent one on November 15th, 2004. I was en-route to Clarkland farms that day when I encountered police cars and a closed Route 108.

Despite the financial strain, no person or animal was hurt. The fire did not appear to dampen the Senator's spirits. Having been a glider pilot, he learned to rise above adversity. In his warm manner, Senator Clark shared his colorful art collection with me. Most of his collection depicts his pastoral landscape.

October's colors are reflected in every inch of this pastoral landscape, "Sheep Down Yonder." The dimmer autumn light is seen in the more earthy tones and lesser contrasts.

On a symbolic level, the colors are reflective of the simple sheep farmer's life. His riches are in the golden leaves, the silvery wool, and the ruby-red fertile ground.

What aspect of color theory would the sheep care about? Only the emerald patch down yonder!

I will never forget the upright fence, winding path, and rolling fields - home of a shepherd and his sheep.

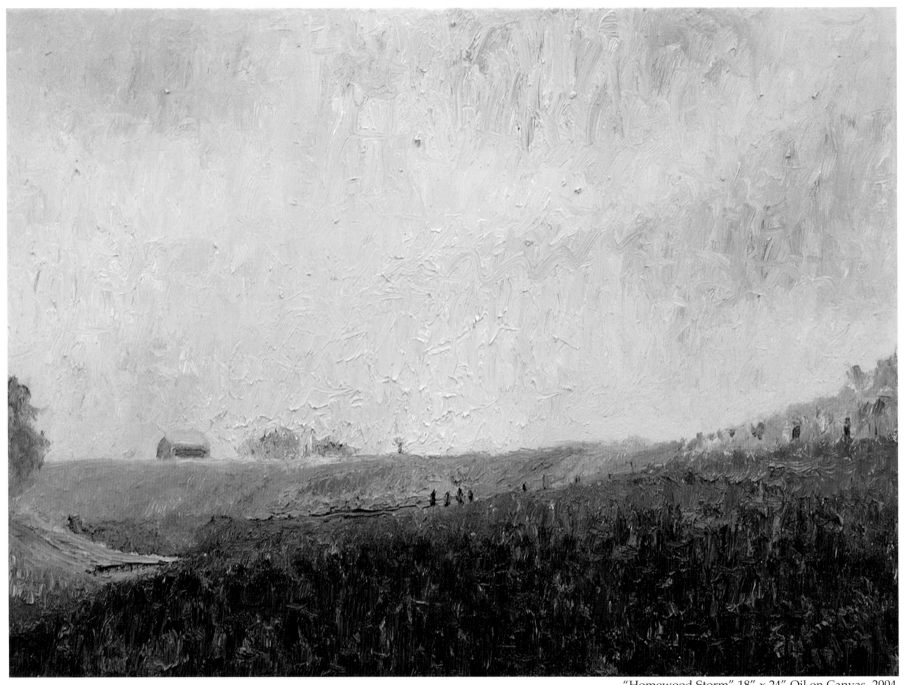

"Homewood Storm" 18" x 24" Oil on Canvas, 2004

32

"Homewood Storm"

Aerial view of the University of
Maryland Clarksville Facility
Photo: Univ. of MD, 1997

One of the few dairy farms left in Howard County is the University of Maryland's dairy farm on Folly Quarter Road. This farm houses over 100 cows kept for milk production, research, nutrition, herd health and behavior. The farm, once known as Folly Quarter Farm, was acquired by the State of Maryland to produce milk for the State Mental Hospitals. In 1957 the State transferred the facility to the University with the stipulation that milk would continue to be produced for the mental hospitals. The stipulation was rescinded in the late 1980s, and the farm's milk production now supplies a local milk cooperative - Land O'Lakes. In addition to dairy research, much research is also done on various grain improvement, insect and pest management, and nutrient projects utilizing dairy farm waste.

Although modern research has improved the methods of farming, mother nature still plays an important role. The annual average rainfall in Western Howard County is about 35-40 inches per year. The required rainfall for a good yield of corn is about 30 inches per year. Although the past two years have been drought free, summer drought may translate into a loss for the local farmer. Other natural conditions such as soil quality, pests, and sunshine are factors that may also affect a yield. Studies have found that average corn yields require about 1-1.2 lbs of nitrogen per acre for each bushel produced, and a soil pH level of approximately 6.2-6.5. For alfalfa, the soil pH should be higher, ideally near 6.8-7.0. Farmers can now control most conditions - except the weather.

Weather conditions also influence landscape painters. The last week in October was stormy - heavy clouds, gusting wind, and cold rain - inspiration for "Homewood Storm." I had originally planned to paint the ponies on Folly Quarter Road, but when I turned around, I saw that the big sky over Homewood Road was in a mood. The heifer shed, fields, road, and trees took on a different meaning than the ones I had painted in the February landscape, "Homewood Bound." In "Homewood Storm," the composition moves from the outer edges of the canvas to the inner center in a slight concave arc. The brooding sky is composed in a convex arc. Symbolically, the sky appears to be pouring itself into a receptive basin. Painting cloudy days is like playing a musical prelude composed in a minor key - the black keys have a melancholic tone - ever so meaningful to the soulful ear.

Bank barn on Folly Quarter Road,
before it was taken down
Photo: Sharon Russell, 1991

I will never forget that heavy, saturated sky above a dry, thirsty ground.

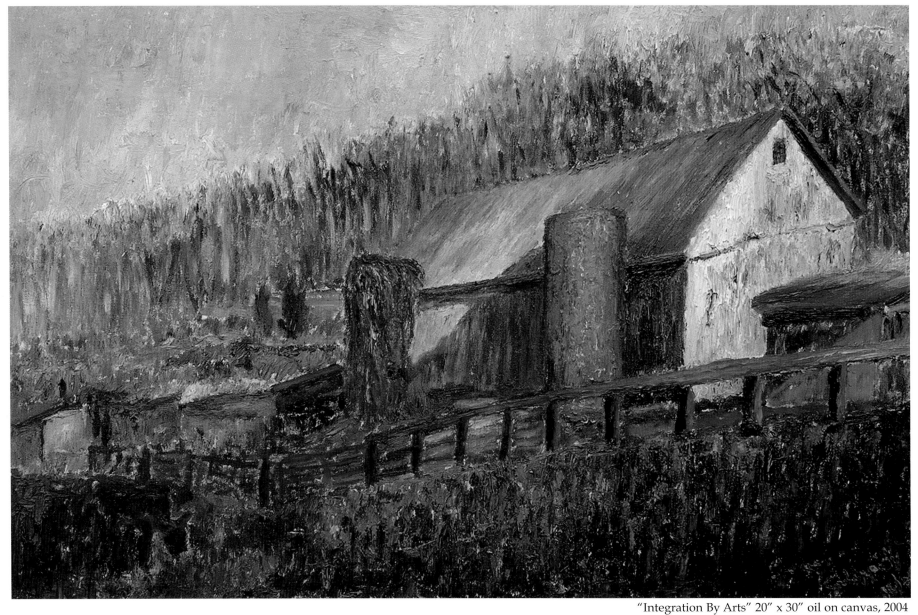

"Integration By Arts" 20" x 30" oil on canvas, 2004

34

"Integration By Arts"

A farm is a place to work the soil and reap
The rewards of grain, produce, cattle, or sheep
Over two-hundred years Cooksville has seen
A Civil War, a Highway and Roberts Inn.

A sunny day in November brought me to the weathered Roberts Inn Farm. This farm borders Route 144 in Cooksville, and is presently owned by Mr. & Mrs. Bell. Roberts Inn Farm was established around 1790, and was run as an Inn by Joshua Roberts in 1824. Mr. Roberts purchased his land from Thomas Cook (hence the town's name). General Lafayette was known to have been a guest at the Inn. During this period, Route 144 was the new Turnpike to the West.

The Inn stood steadfast during the Civil War - a few pieces of shot were recently recovered from the stucco on the front of the Inn . Photo of Roberts Inn is on "Contents" page.

The property changed hands many times and the Bells purchased the 19+ acres in 1977. The Bells raise beef cattle, two kinds of sheep (Hog Island & Montadales) and donkeys. They sell the cattle as meat and pure bred. The silos on the property are reminders of the time when the property was once a dairy farm. The weathered wood silo is very old and rare.

Mrs. Bell recalls when Route 70 was a two-lane road, farming was still the region's livelihood, and family members dressed up to eat dinner at home. The Bells are currently nominating the Inn to be integrated into the county's Historic Preservation Program.

"Integration" has several connotations: incorporating into; relating one with the other; and mathematically, the relationship of the parts to the whole. Artistically, I try to find ways to integrate the numerous concepts of composition and color. In "Integration By Arts," the elongated "S" curve makes up the composition: the fence in the foreground travels in an "S"; the tree-line in the background is an "S"; and the shadows from the top right corner to the bottom left corner move in an "S." The entire painting moves from a large mass to incrementally smaller masses and from bright reds and yellows to cool blues and purples, in the shape of an "S." Mathematicians, take note: this is pure "Integration by Arts!"

I will never forget the cacophonous integration of the highway traffic roars with the farm animal calls.

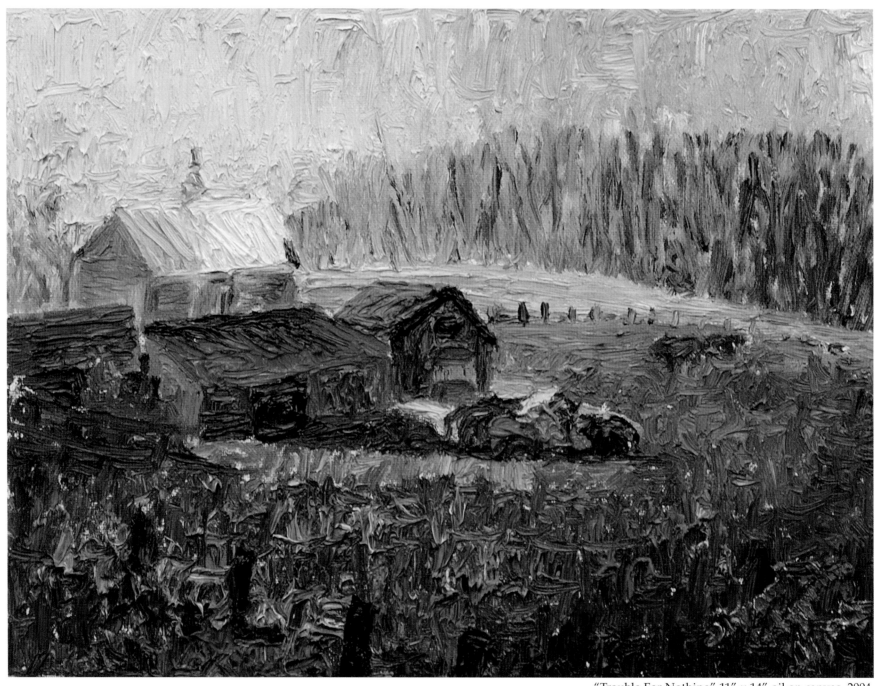

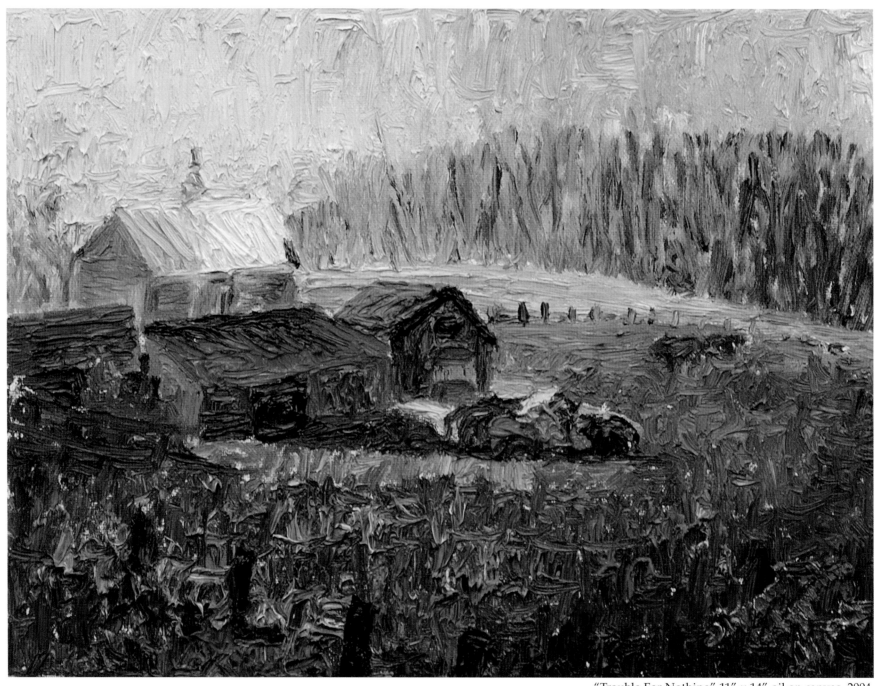

"Trouble For Nothing" 11" x 14" oil on canvas, 2004

"Trouble For Nothing"

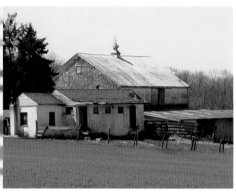

Dairy barn on Trouble For Nothing Farm, 2005

Mount Airy sits on the Western tip of Howard County, the Eastern segment of Frederick County, the Northern part of Montgomery County, and the Southern end of Carroll County. Mount Airy is quiet, open, and pristine. At noon, the cattle come close to the barns to feed on the haystacks. An occasional traveler drives by on Long Corner Road. A solitary landscape painter such as myself is the only element outside this perfect harmony - a harmony only a farmer would truly appreciate. "Trouble For Nothing" was the original name of this farm - a fitting name - for perfect peace and harmony.

This farm encompasses 123 acres and was purchased by George and Margaret Holtzinger in 1949. At the time, it was a dairy farm, and still houses one of the first milking parlors in Western Howard County. Jeff and Eddie Harrison purchased the farm in 1983. They raise beef cattle and grow corn, soybeans, wheat, barley, and hay. The Harrison brothers continue to operate this family farm today.

Mt. Airy, being the Western most point in Howard County is the last place I would have expected to meet an acquaintance of an acquaintance. I was born and raised in Colombo, Sri Lanka and have been socially acquainted with Sir Arthur C. Clarke, the famous Science Fiction writer. While painting, a resident across the street from the farm asked me from where my roots were. He mentioned Sir Arthur and said that he was a childhood fan of Sir Arthur's, and that he owned a collectible autographed postcard. This short conversation made me realize that life sometimes works in a spiral - experiences from our "outer " world spiral into our "inner" world.

A spiral can be traced in the composition of "Trouble For Nothing." It starts at the fence on the outer left corner and moves through the shadows in the field to the tree line in the background, to the barns in the left middle, then to the center cattle-feed, and finally to the inner red patch depicting a bull. Similarly, experiences from our "outer" world could work into our "inner" world and culminate in a "bull's eye!"

Pond on Trouble For Nothing Farm, 2005

I will never forget painting away my troubles here in Mount Airy.

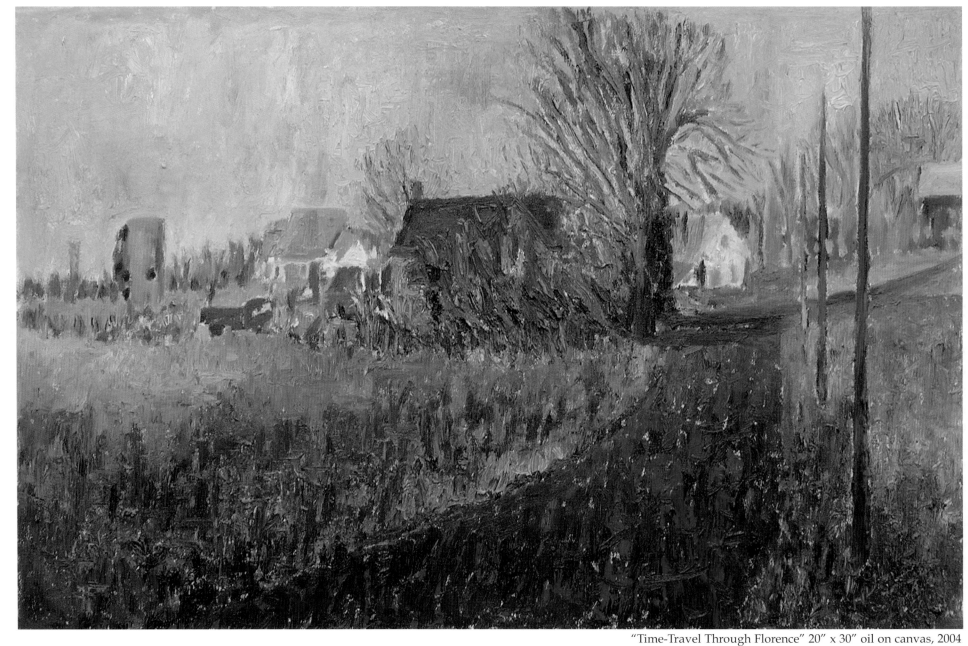

"Time-Travel Through Florence" 20" x 30" oil on canvas, 2004

38

"Time-Travel Through Florence"

Florence is a town with winding roads in Howard County
Much like Florence the city with winding roads in Italy
One claims the handwork of Da Vinci and Michelangelo
The other claims the land work of Mullinix from long ago.

Florence is located just south of Mt. Airy. This particular farm, belonging to the Mullinix family, caught my eye because of its broken-down silo.

David Mullinix farmed 800 acres (200 of which he owned) here in Florence his whole life, until his death in 2004 (at age 72). Over the years, this farm raised beef cattle and grew wheat, soybeans, corn, and barley. The farm was originally purchased by the Mullinix family for about $5.00 per acre during the late 1800s. David Mullinix, his parents, and his grandparents lived here all their lives. Three generations ago, the family owned about 6,000 acres in Western Howard County. David Mullinix's parents used to own a flour mill, and its millstone was turned by water. They also had a store that sold meats and various necessities. David's widow, Kathryn, fondly remembered David's aunt. The aunt owned a dog that would carry a basket with a shopping list to the store. The clerk would fill the basket, and then, the dog would carry the goods back home. Kathryn's grandson, Jesse Thoresen, recently recalled when a T.V. weatherman spoke of a snowstorm that was going to hit the "Mullinix" region of Maryland.

Florence, Italy (also known for its Market Production of fruits and vegetables) was the work place of Da Vinci and Michelangelo during the Renaissance. Da Vinci was one of the first to work with perspective and the concept of a focal point. Michelangelo believed in expressing the inner soul (the pathos) of his subject matter through gestures and expressions.

In "Time-Travel Through Florence" the road, the light posts, and the branches of the tree, seem to follow Da Vinci's perspective theory and converge at the sun-lit house. The dilapidated silo and overgrown shrubbery follow Michelangelo's pathos theory.

In addition to Renaissance theories, I am increasingly influenced by theories of physics. In Albert Einstein's Special Relativity theory, space and time are inter-connected and time slows down when traveling through space-time. I wonder, if traveling greater than the speed of light through Florence, one could see the past (pre-dilapidated silo and shrubbery), the present (gold house with branches pointing toward it), and the future (red barn at the end of the road)? No matter the theory, life is about where you have been, where you are right now, and where you are heading.

I will never forget the dilapidated silo, a piece of yesteryear, here today, and the years to come?

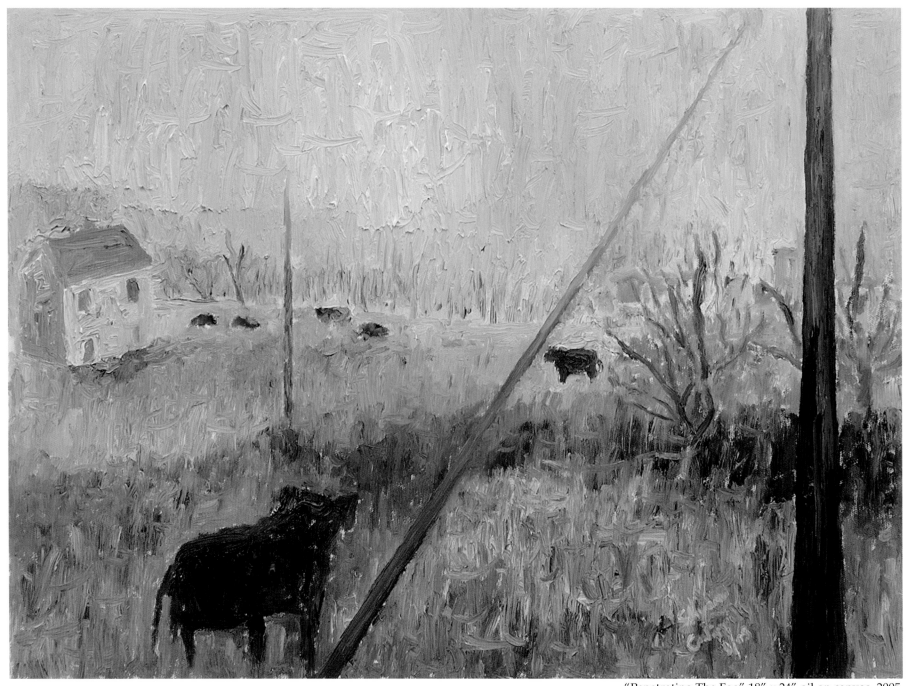

"Penetrating The Fog" 18" x 24" oil on canvas, 2005

40

"Penetrating The Fog"

Bob Harless at the dedication ceremony
of the Liberty Baptist Church, Lisbon
Photo: Ferguson family, 1997

A warming trend during the second week in January brought me out to this farm located along Route 144 in Lisbon. The farm's name is Trail Farm, and it belongs to Mr. James Ferguson and his family. This farm originally belonged to James' brother, Marion "Bob" Harless, who purchased it in the early 1980s. In the mid-1990s, Bob gifted a parcel of land to the Liberty Baptist Church. James purchased 80 acres from his brother Bob in 1995, before Bob passed in 2003. In the early 1900s, the property consisted of 200 acres, and stretched as West as Poplar Springs. At that time, it was a dairy farm.

The Fergusons currently use 40 acres to grow corn and grain crops, and the remaining 40 acres to raise beef cattle. Although there are incentives to sell the land for a handsome profit, Mr. James Ferguson plans on farming his land as long as it remains a viable business for himself and his family.

January occasionally has a few days with above average temperatures. This particular Wednesday was about 45F, and a heavy fog covered the area. Just as classical theories of art drift in and out of my head, modern theories of art also come and go. Many modern works (Pieta Mondrian's work) are known for compositions within compositions.

On the right hand corner of "Penetrating The Fog" there is a vertical rectangle emphasized by the foreground telephone pole. In the center there is an isosceles triangle defined by the telephone pole and the diagonal cable that supports it. To the left of the cable is an apparent inverted isosceles triangle. The remaining rectangle is to the left of the canvas. The cattle are the unifying element - placed from left front to right-center and then to the back. Since there was no sun on this foggy day, spatial relationships had to be created without the use of light and shadow. More intense colors and larger sizes are used for the foreground, and diminishing sizes and shades are used for the background. While painting, I truly experienced the entire landscape - the rustic house, the rich ground, and the slight balms in the air amid a January deep-freeze.

Farmer Bob in his soybean fields
Photo: Ferguson family, late 1990s

I will never forget the penetrating presence of the cattle as the fog gently trailed away.

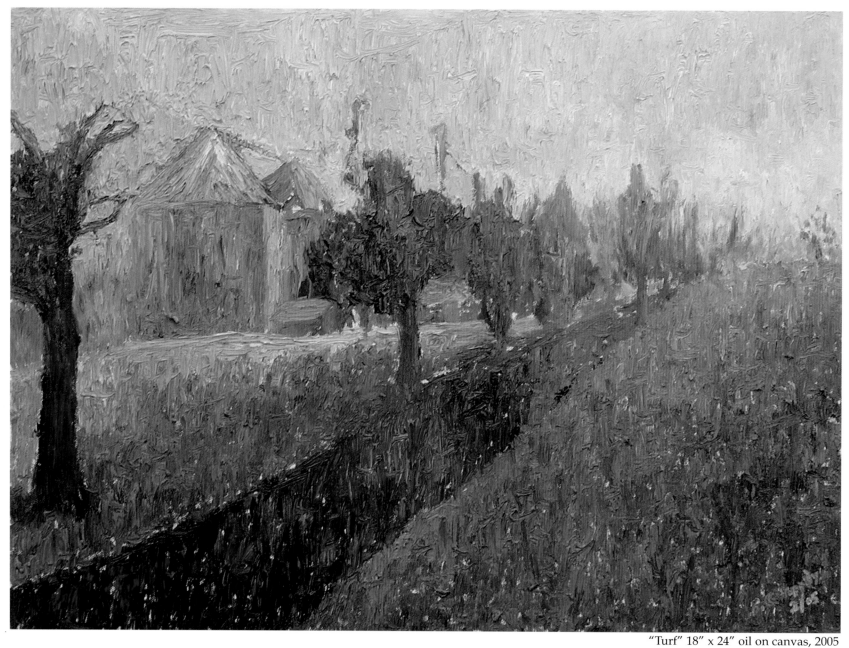

"Turf" 18" x 24" oil on canvas, 2005

"A Deep Cold Winter" & "Turf"

Grain and turf-grass are essential commodities
That some folks produce for local communities
One provides for animals in farms and recreation
The other provides green lawns for the population.

Painting outdoors during the winter is something most people would consider to be "down right crazy." I could not help being drawn to the warmth of a fiery-red barn along Daisy road, in Daisy. The horse and goats did not seem to mind that it was about 10°F outside, and that their ground was covered with several inches of January snow. However, my fingers and toes froze as I stood outside to capture on canvas "A Deep Cold Winter." This painting, which emphasizes the contrast of warm and cool, can be found on the "Copyright" page.

February usually shows signs of a thaw from winter's deep freeze. Once again, I found myself outdoors - this time in Southwestern Howard County - Glenelg. With thawed fingers, I stood alongside Triadelphia Road to paint "Turf."

A 2001 Economic Profile for Howard County showed a large increase in the "Green Industry." There were 98 Horticulture/Nursery/Turf-sod operations on 46 farms covering approximately 1544 acres. Turf grass was reported to be the best solution to destruction (soil erosion) of environmental quality. Over 44 percent of their products are marketed to buyers within the county. The number one reason is the increase in new home and office-complex construction. A prime customer, Toll Brothers Inc., home-builders, who are building across the road from a well-known grain and turf farm.

New homes are always a good indicator of healthy economic growth. Economic literature tells us that as household incomes grow, demand patterns shift away from the basics toward bigger and better homes, more manufactured goods, efficient public services and facilities, and a variety of other luxuries of modern living. Such changes combined with population growth, rising land prices in urban centers, and automobility, contribute to a gradual urban sprawl into rural farmlands.

In Howard County, new homes come in various shapes and sizes. To meet the needs of the increasing population (from 250,720 in 2000 to 303,500 in 2020), the county continues to see an increase in condominiums, single-family homes, and 50+ communities. Although economic profiles vary widely with location worldwide, Howard County is a prime location to live for its schools, services, and green picturesque landscapes.

Green is certainly the dominant color on "Turf." Although it was February, I could see a sea of green poking out of the thawing ground. The green served as a contrast to the large steel silos (depicted in shades of purple) in the background mist. The trees leading up the private road are symbolic of a family's roots. Painting on Triadelphia Road was like watching history in the making. Across the road from this turf farm was the construction of new homes - an example of a healthy county's changing landscape.

I will never forget the massive silos that loomed up into view through a February mist.

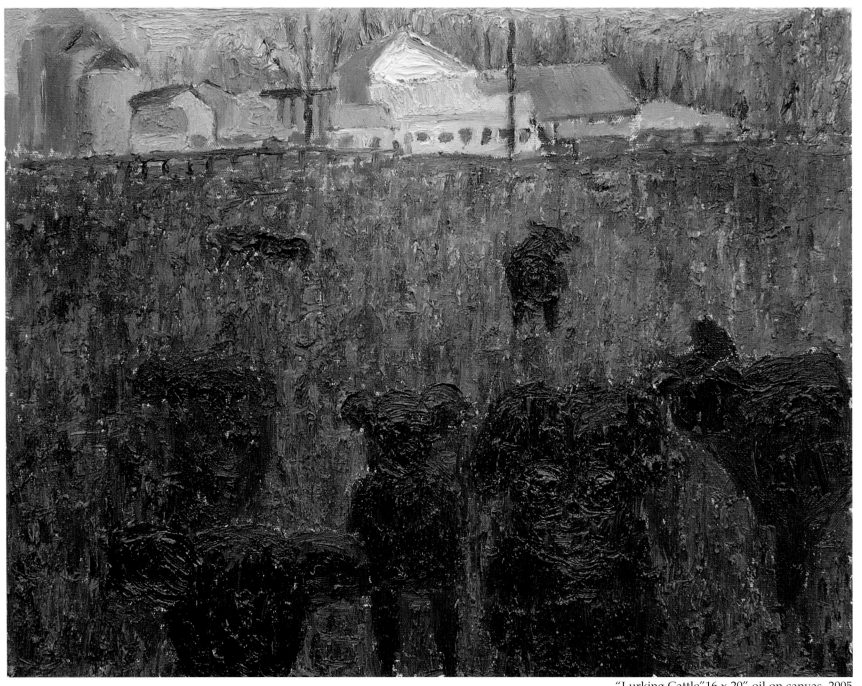

"Lurking Cattle" 16 x 20" oil on canvas, 2005

"Lurking Cattle"

Construction site on Triadelphia Road, Glenelg, 2005

This Mullinix Farm is located on the corner of Howard Road and Triadelphia Road. The Mullinixes of Glenelg are distantly related to the Mullinixes of Florence. John David Mullinix married into the Musgrove family in the 1930s. The 124-acre property was originally a dairy farm that also raised chickens and pigs. In addition to farming, John David was in the trucking business. He transported produce from Baltimore to local stores in Howard County. In 1940, John David and his son went into the business of selling and servicing tractors and farm equipment.

John David's grandsons, the present day Mike, Steve and Mark Mullinix, raise cattle, and grow field corn, soybeans, wheat, barley and oats. Mike's teenage son Mike Mullinix, Jr. won Howard County's Youth Ag-Business Development grant in March 2005. Mike Jr., his brothers, and cousin grow and operate a sweet-corn business. The young Mullinixes are well set into being the bright entrepreneurs of tomorrow.

The setting late afternoon sun made the background barns and silos bright, but left the foreground cattle in shadow. Shadows not only surround and help define positive, illuminated space, but they have significance for what is lurking within them. Throughout various periods of art, many artists have intrigued a viewer by placing objects in shadows. Some examples are Degas' "Prima Ballerina" of 1876 and De Chirico's "Mystery and Melancholy of a Street" of 1914.

The Mullinix cattle were minding their own business when I came up to their fence to paint "Lurking Cattle." To them, I must have looked like an alien in a hooded coat, wrestling a three-legged contraption to hold up a rectangular white object. One by one they appeared through the shadows of the setting sun. Their curious eyes seemed to say, "You must be from other parts of town - we can tell by your strange colors and scents. We believe that there's nothing like the fresh smell of mud, grass, and musk!"

Front drive and tractors on Mullinix Farm, 2005

I will never forget those eyes in the shadows wanting to know what breed of human I was.

45

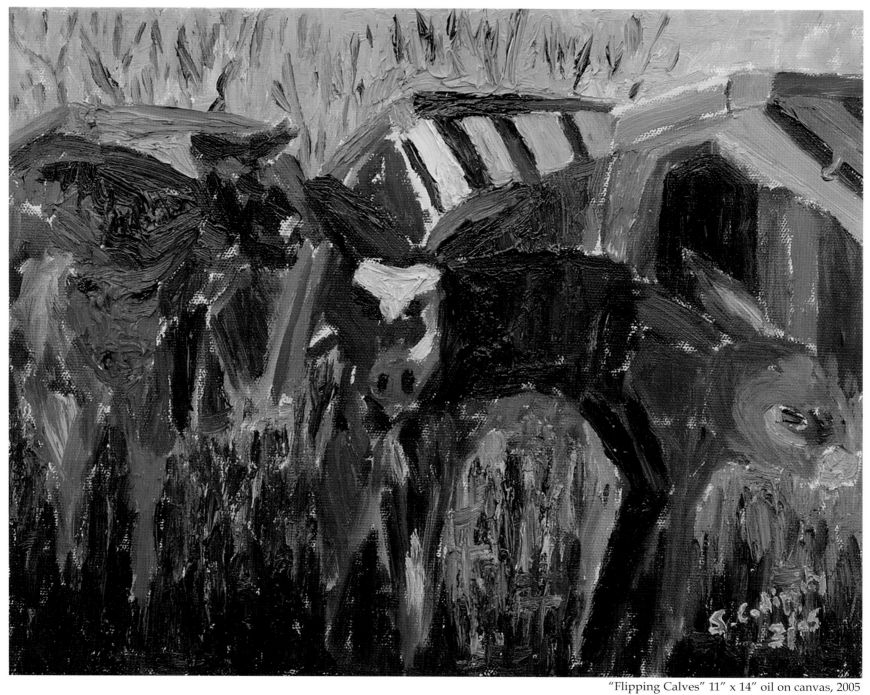

"Flipping Calves" 11" x 14" oil on canvas, 2005

"Flipping Calves"

Maaa, Maao, Maoo, Mooo were the calls
Of Belden David Patrick's three-week calves
Struggling to feed and stand - this way and that
In a brand-new world of sky, grass, and a cat!

Spring is just around the corner, and these newborn calves are the epitome of new life! They simply could not stand in one spot for longer than a second. In early March, two-dozen calves were born on Maple Dell Farm, which belongs to Belden David Patrick III and his family. Located on Daisy Road in Daisy, MD, this 93-acre dairy farm (now in preservation) was originally owned by Mr. Patrick's grandfather.

The calves are kept on this farm until they are about three months old, and then transported to another of the Patrick's farms located in Woodbine, about 4 miles North of Daisy. The cows are bred every 13 months. The gestation time is 283 days, and most of the calves are born in the Fall. Mr. Patrick is proficient at breeding cows by both natural and artificial methods.

The farm is operated by Mr. Patrick, his two sons and their wives. When there are large labor-intensive projects such as spreading manure or moving the calves from one location to the other, the Patricks employ additional personnel.

Movement and structure were revolutionary concepts that were first introduced by cubists such as Picasso in his "Les Demoiselles d'Avignon" from 1907 and George Braque in his "Violin and Palette" from 1909. This style was later expanded upon by Marcel Duchamp in his "Nude Descending the Staircase" from 1912.

Motion is truly the order of things. Back in the 1600s, Newton defined the world as being in constant flux: "Nature is a true circulatory worker, creating fixed states out of volatile and volatile out of fixed."

Painting objects in motion is an interesting challenge. In "Flipping Calves," there are only two calves, but each is placed in two different poses, because they flipped back and forth constantly. The calf on the right had a frontal pose for a second, and then flipped to a lateral pose. The two poses share torso and legs. Similarly, the calf on the left is painted with a single hind.

The colors in the frontal poses are depicted in deeper, more intense colors, and the lateral poses are depicted in less intense tones. Sprightly movement is also described with the angular brushstrokes, as seen in the calves, the little sheds behind the calves, and in the tree branches. Motion is the pure definition of a Newtonian World!

I will never forget the excitement of these calves at seeing a brand new world that included a cat!

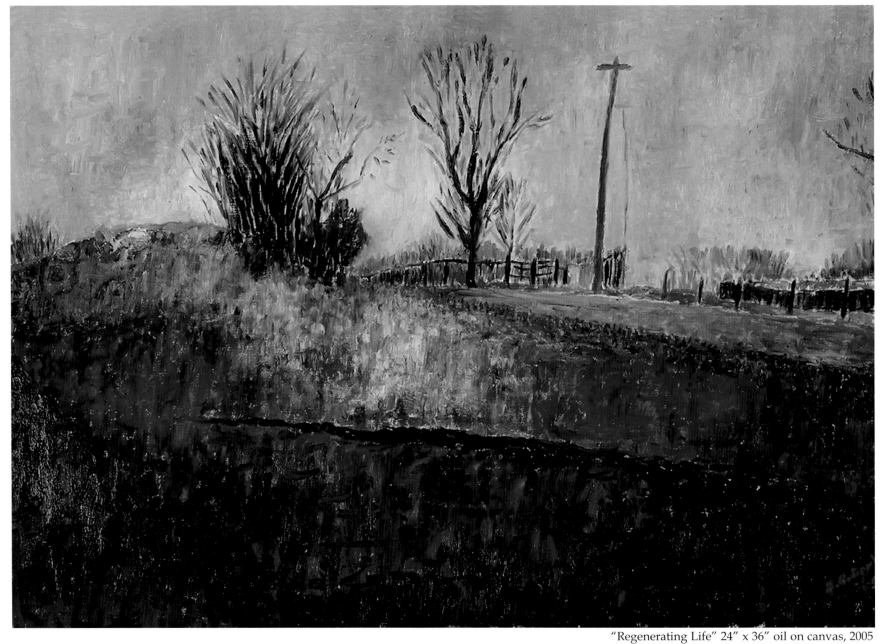

"Regenerating Life" 24" x 36" oil on canvas, 2005

"Regenerating Life"

Pond on Brendel Farm, 2005

Good Friday is a solemn day in the Christian world. This was the day I painted the Clevenger Farm with its cemetery, on Carr's Mill Road, off Route 97 in Glenwood. Dr. Charles Alexander Warfield (participant of the burning of the *Peggy Stewart* and married to Elizabeth Dorsey) along with the original Mullinix, Hooks, and Dorsey are buried here. Dr. Warfield settled here in the late 1700s. Then, the property was 1300 acres and called Bushy Park. The Clevengers purchased their 200-acre farm around 1979. They grow corn, soybeans, wheat and barley. Linda and Cliff Clevenger and their youngest son work the farm. Their other children also help during the peak of the season. The Clevengers are actively involved in county forums regarding the development of their surroundings.

The Allen Farm (160 acres), which is across the street from the Clevenger Farm, was sold to the county in 1994, and is currently being developed into the Western Howard County Regional Park and Community Center. The site will include a senior center, double gyms, and recreational facilities. Mr. Bill Brendel, who owns a 150-acre farm on Union Chapel Road (between the Patrick Farm in Daisy and the Clevenger Farm in

Glenwood), observes, "change is everywhere, and you can't stop it. Urbanization is creeping into rural areas."

The creeping impact on the Clevenger Farm is evidenced by mud from the excavation that runs off into the streams on their property. The proposed stadium lighting on the playing fields are also a concern, since "all-night illumination" is contrary to the pastoral life-style that the farmers enjoy.

Symbolism is a method in which artists over the years have illuminated their subjects at hand. Artists such as Jan Van Eyck in his "Wedding Portrait" of 1434, and Mondrian in his "Bloeinde Appelbaum" of 1912, have given significance to their subjects by the symbols surrounding them. I was immersed in symbolism as I painted "Regenerating Life" in the excavated grounds of the Western Howard County Regional Park on Good Friday. As I was standing in a "grave," I looked up and saw a cross (a power-post) in front of me, a cemetery to my right, and tombstones (boulders) to my left. Although I appreciated the nostalgia of bygone times, I also viewed the cross as a symbol of resurrection and rebirth. The crater was not only a symbol of the past, but was also the site where new life was about to spring. The park will soon fill the air with the sounds of children playing and families picnicking.

Construction equipment at Glenwood Community Center site, 2005

I will never forget the circle of life - where the old gives forth to new - the "Good" in Good Friday.

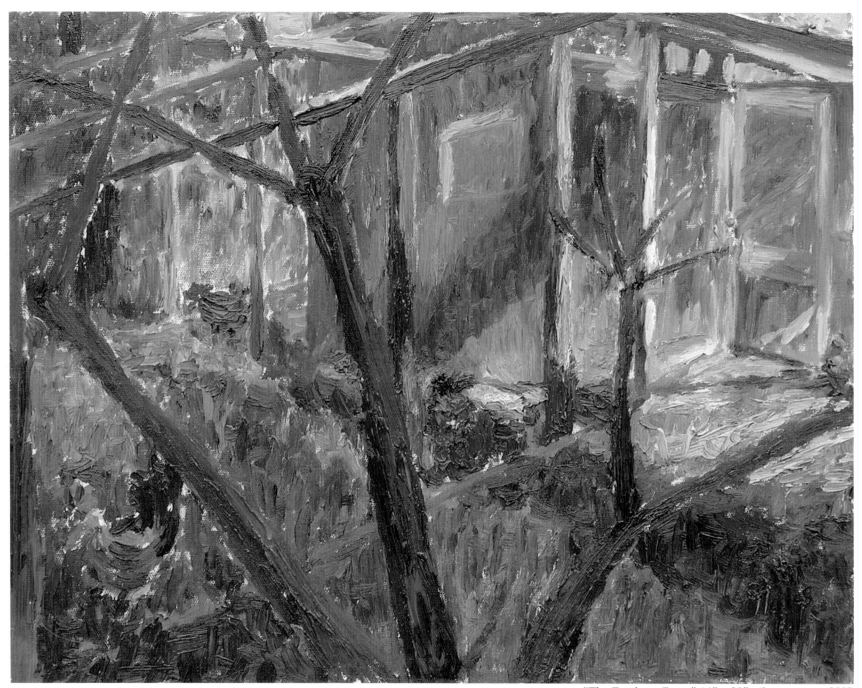

"The Feathery Front" 16" x 20" oil on canvas, 2005

"The Feathery Front"

Cuck-ka-doodle-doooo, Cuck-ka-doooodle-doooooo
Went the trumped up rooster a few times during the morn
Cluck-cluck-claaaak, clucka, clucka, cluck, cluck, claaak
Went the hen from morn thru noon thru the next dawn.

Mount Pleasant has always been a haven for creatures, no matter the tune or the rhythm. The feathered creatures in the coop are raised to produce fresh eggs. The beehives in the meadows produce honey, which is sold along with the eggs. The lush 232 acres and two streams provide nature lovers with opportunities for bird watching, hiking, fishing, and habitat exploring. Where is this haven? It is in Woodstock, located on Route 99, parallel to Route 144, Northwest of Route 29.

In 1692, Mount Pleasant was given to Thomas Browne, a Patuxent Ranger, who was commissioned to protect the frontier, survey the headwaters and keep watch on the Susquehannock Indians in Woodstock.

His last descendants, Ruth and Frances Brown, gave the farm to the Howard County Conservancy with the stipulation that it be preserved in its natural state. Since the Brown sisters were active educators (a combined total of 96 years) within the county, Mt. Pleasant continues to foster education. The Conservancy opened its new Gudelsky Environmental Education Center on June 3rd, 2005.

Heralding the new day is certainly the main task of the rooster. Keeping the rest of the day alive and kicking seems to be the task of the hen. As I arrived, I was greeted by the trumpeting of the rooster. Nature's music is often imitated in the visual arts, either realistically or abstractly. In "The Feathery Front," I was influenced by the rooster's piercing trumpeting, so I "pierced" the rectangular canvas with strong diagonal lines (tree branches) in shades of red. The diagonals influence the eye to travel from the left foreground shadows to the right background door, which heralds the morning light.

As I painted, I noticed that the hen simply kept on clucking incessantly after the rooster. I suppose the same has been observed in human behavior. The male declares himself in the morning, and the female nags all day long.

As I further observed the fowl, the rooster had finally had enough of the clucking and gave the hen a roll in the hay. Shortly thereafter, the clucking stopped, and all was quiet on the feathery front. I have observed the same in the human world, too!

I will never forget Mt. Pleasant's sounds that were a musical symphony to those who stopped to listen.

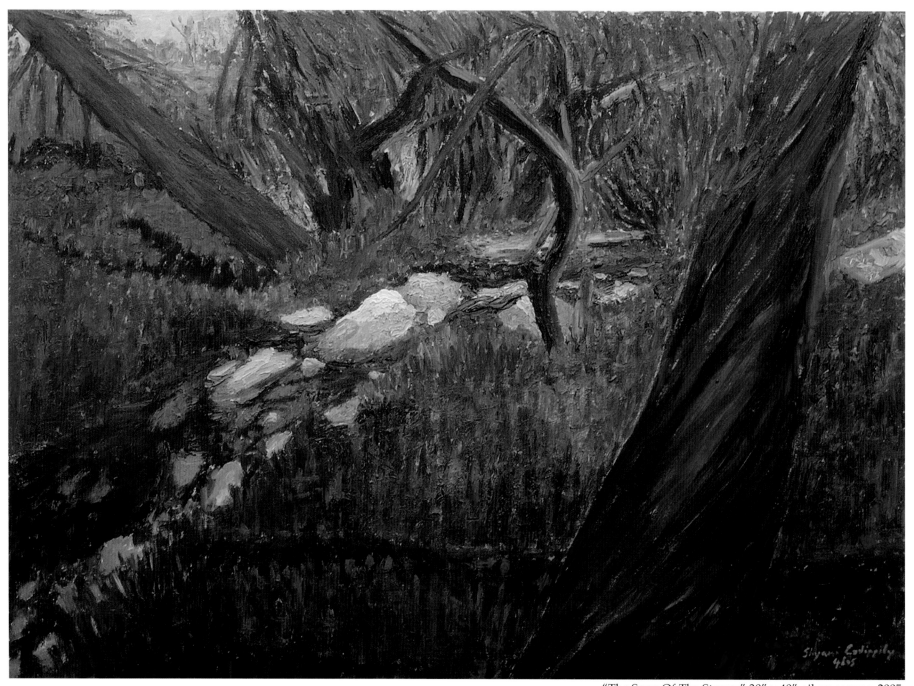

"The Song Of The Stream" 30" x 40" oil on canvas, 2005

"The Song Of The Stream" detail

"The Song Of The Stream"

The Brown Farmhouse, 2005

Reflecting back in time to 1692, I can picture a young Thomas Browne clothed in leather hide with shotgun in hand, surveying his land. He probably measured the acreage with his feet and spanned distant landmarks with his hands. In order to watch over the Indians he probably sat atop a hill, and kept his eyes and ears opened to their activities. When not observing the Indians, Mr. Browne was probably chewing on bark and exploring nature.

Ranger Browne built a one-room log cabin, which is now a living room for the Conservancy's tenant. In 1715 Mr. Browne died, and left the lower part of Ranter's Ridge to his youngest son, Joshua. Joshua's grandson, Samuel Brown (the "e" had been dropped over the years) inherited and acquired the farm as it exists today.

Samuel added a second story to the log cabin and in 1865 added a front wing. During the Civil War, Samuel housed General Bradley T. Johnson - who was bathing in the attic while Union soldiers searched for him. At the same time, Union soldier Captain Faithful was courting Samuel's sister, Kitty. There is no documentation of a scandal.

Samuel was elected to three consecutive terms as Commissioner of Howard County, and was instrumental in constructing the Ellicott City Jail where his name is inscribed in stone under the front gable.

In 1880 Samuel Brown died, and his youngest son Frank de Sales Brown, became the sole owner of the property. During this time the barn, carriage house, granary and corn house were mysteriously destroyed in a fire, and he constructed the existing outbuildings which include a carriage house, blacksmith shop, bank barn, wagon shed, corn crib, smoke house, and two hen houses. Frank Brown died in 1911, and left the property to his three children, Samuel, Ruth, and Frances.

When Samuel (son of Frank de Sales Brown) died in 1974, he left his portion to his two sisters, who are famously known as the Brown Sisters. They were both teachers in Howard County, and Ruth Brown taught County Executive, Jim Robey. The sisters both passed away in the early 1990s and left the property to the Howard County Conservancy to maintain in its original state. The Conservancy received 127 acres (of which 45 acres were sold to the Department of Recreation and Parks) and the Department of Natural Resources - Patapsco State Park- received 105 acres. Among its wonders are 26 acres each of restored forests and grasslands. The Conservancy manages the entire property.

Ruth Brown, 1943
Photo: The Bandel family

Nature's wonders can be seen and heard throughout the 232 acres of Mt. Pleasant. One morning, it was my desire to paint one of the streams on the property, so I hurried over to the old farmhouse to obtain a map to the stream. The map did not have a "You Are Here" label or a "North-South" symbol. It did have locations of the exterior structures, including a vegetable garden. I made it as far as the garden, and then came to a fork with three widely open paths. I could not decide which way to go and then realized that I did not need a map. I needed to open my eyes and turn on my ears. I needed to follow the tree line that wound around to the bottom of the hills. I needed to listen for flowing water. Within minutes, I was at the most beautiful bubbling stream. It had glistening rocks, entwining shrubbery, scurrying groundhogs, and skinny-dipping insects. I had arrived at my destination!

Arriving at one's destination or realizing one's destiny is a concept that validates one's existence. While painting outdoors, I often have a chance to reflect on my own destiny. Artists throughout history have met many challenges and broken barriers to create their woks. When Edouard Manet painted "Luncheon on the Grass" in 1863, a scandal erupted, because exposing the female nude in front of clothed gentlemen was against societal dogma. Similar scandals have occurred since then, but the artists have persevered. Although my subject matter is not considered scandalous (at least not yet), I believe in conveying emotion and sensuality. When observing nature, I notice the various emotional and sensual qualities among it that create "music." In "The Song Of The Stream," two trees have an upward aggressive quality that is balanced by the horizontal, passive tree in the background. The glistening rocks among the flowing water are a soothing contrast to the overgrown entwined shrubbery. The calm blue sky is a foil to the ground, which is filled with twigs, critters, and debris, including a "Ryan Homes" sign, seen in the far right of the painting. Although I have no qualms about new construction, the farm adjoining Mt. Pleasant will see many new homes. This sign, which had blown over from another construction site, is simply a discordant note to nature's music.

The history of Mt. Pleasant continues to unravel. The Maryland Archeological Society has started to conduct digs in collaboration with Howard Community College. Within the walls of the new Gudelsky Environmental Center, students will learn much about the nature and music of Mt. Pleasant!

The Gudelsky Environmental
Education Center, 2005

I will never forget the bubbling stream that sang the most beautiful Spring melody.

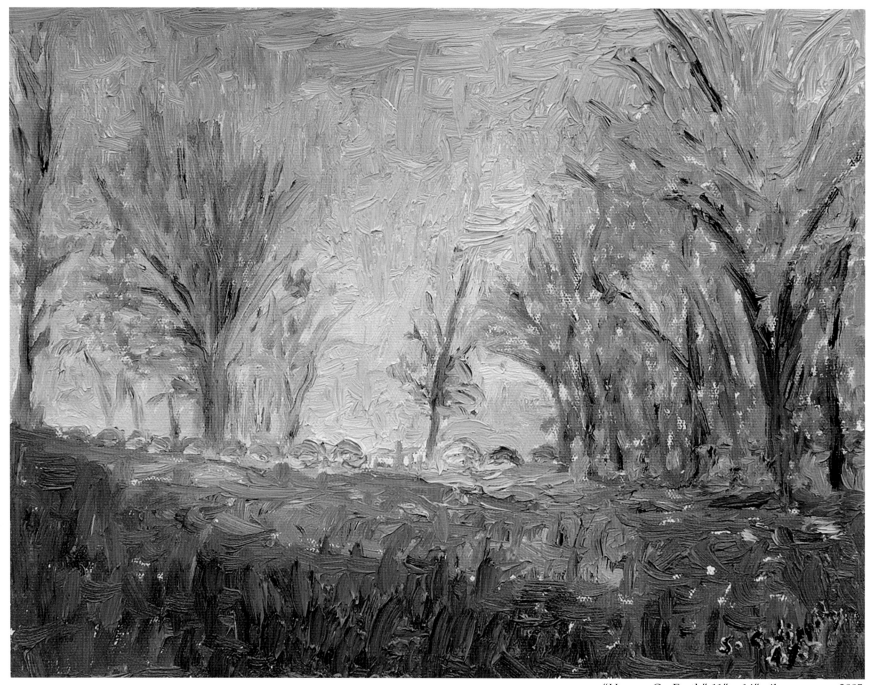

"Heaven On Earth" 11" x 14" oil on canvas, 2005

"Heaven On Earth"

> *Haystacks in the distance of a country road*
> *Were in my view on a field of green and gold*
> *I could see they touched the heavenly sky above*
> *As they spoke of a farmer's daily labor of love.*

Marriottsville is located at the Northern tip of Western Howard County, and is bounded by Carroll County to the West, and Baltimore County to the East. The Patapsco River and Patapsco State Park run through Marriottsville. Across the street from Alpha Ridge Park there are 885 acres of land owned by the State of Maryland. Within these rolling acres there are bales of hay in the distance, creating a picturesque sight to the passer-by.

Mr. Ron Stevenson has been leasing this state owned farm, called Marriottsville Ridge, for over 35 years. On about 300-350 acres he grows, cuts and bales hay for sale to various equine farms in Howard and Carroll Counties. His daughter operates a horse farm on about 500 acres of the property. Jay Harrison, of Twin Ponds Farm in Woodbine, MD, used to cut the hay for Mr. Stevenson, up until 10 years ago. During his 5 years of employment, Mr. Harrison struggled with the challenges of Marriottsville's hilly terrain. Although Mr. Stevenson laments the dwindling farming community, these rolling acres of Marriottsville will be in his field of view for years to come.

Landscape painters over the centuries have had a true appreciation for the "field of view" aspect. They were inspired by what they saw, and they found ways to explore the land's sensations artistically. The field of view in "Heaven On Earth" is the big open field with trees leading up to the bales of hay. This is set against a backdrop of blue sky with puffy clouds. A farmer who works his land to earn his living has a true appreciation for the land's sensations.

The Impressionist painters were the most successful at conveying the concept of the "field of view." Although Monet and Van Gogh were well known for their conveyance of this quality, a less famously known French painter was François Millet. Millet understood the farmer's field of view, and conveyed an earthiness in his paintings, "The Sower" of 1850, and "The Gleaners" of 1857. In many of Millet's works, the fields and the sky seem to share an endless boundary.

I will never forget the good earth that was within my field of view, and stretched into the heavens above.

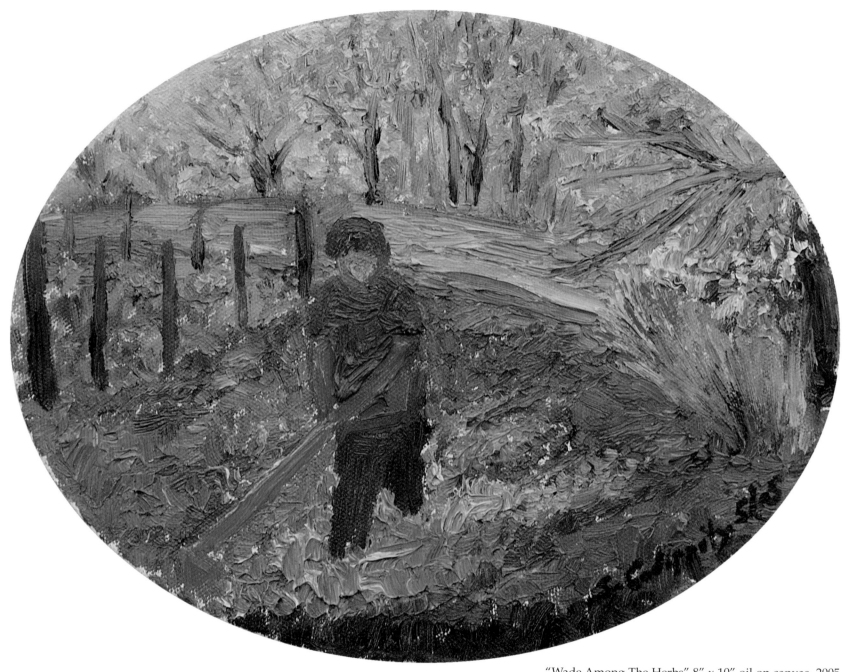

"Wade Among The Herbs" 8" x 10" oil on canvas, 2005

"Wade Among The Herbs"

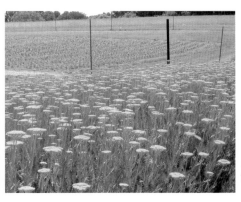

A field of Yarrow
Stillridge Farm, 2005

Stillridge Herb Farm is located to the East of Mt. Pleasant on Route 99, in Woodstock, Maryland. In 1972, Mary Lou Riddle's love for nature and growing herb plants expanded into a business. With the encouragement of Ruth and Frances Brown of Mt. Pleasant, Stillridge Herb Farm was established.

Today, Mrs. Riddle and her daughter, Deborah Amoss, sell their crafts at the three business locations they own - one on the property, one in Old Town Ellicott City, and one in Annapolis. Her son Wade, with the help of employees, transfers over 300,000 newly seeded plants into the fields every Spring. Later, time is spent harvesting and drying the fragrant crop before the frost. The following Spring, the process begins again, with great hope for a gentle growing season.

Stillridge's customers delight in the farm's natural beauty, and the colorful fields filled with herbs and flowers. They purchase flowers and herbs to plant in their own gardens and to create aromatic potpourri.

Fresh aromas are also a painter's delight. Trying to convey any of the five senses is always a challenge. This herb garden not only looked green, but it smelled green, too. To have the greens vibrate, I mixed in an abundance of red (green's opposite in color theory). Although I utilize this and other theories, I often find myself being completely immersed in my subject, and the rest just flows!

Formulas and theories can be learned in any field, but it is the many experiences and personal touches that make one's craft or business successful. Mrs. Riddle may have learned the correct soil pH for planting seeds in a pot, but her years of experience with climate conditions, planting and harvesting techniques, arranging and displaying of bouquets, and personal customer service, is what makes her unique and successful in her own field!

Bee-balm in bloom
Stillridge Farm, 2005

I will never forget Stillridge's fragrant and colorful fields.

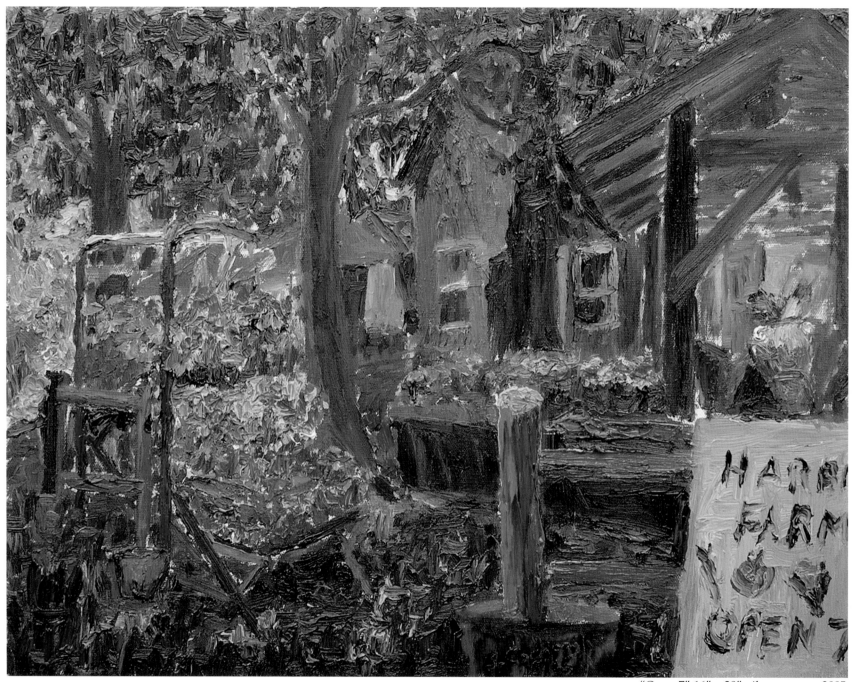

"Open 7" 16" x 20" oil on canvas, 2005

"Open 7"

At Harbin's produce stand people gather
To mingle, catch up on local news and chatter
About the potted flowers, vegetables and fruits
Of a family that in Ellicott City sowed its roots.

To the Northwest of Route 29, at the corner of Route 99 and Old Mill Road lies Harbin's Farm. Brothers George and Andrew Harbin (now deceased) came up from Tennessee during the 1930s and established a 1,000-acre farm. Their property stretched from Route 29 to what is now Route 70.

Over the years, the Harbins had sold parcels of their land to developers for new homes and to the county for roads such as Route 70. Robert Harbin and his niece Kim Taylor now run the produce business on 18 acres, which is a piece of the original farm. Until recent times, the Harbins grew corn and tomatoes as their primary crops, which they sold to the A&P (now Super Fresh) and to Acme Foods. In the past, other crops were grown on a smaller scale to sell at the stand they operated at the intersection of Routes 29 and 108.

About thirty years ago, the Harbins opened their corner market in Ellicott City. Of the produce they sell, approximately 30% (which include tomatoes, cucumbers and peppers) is homegrown. The rest is brought in from Carroll County, the Eastern Shore, and Lancaster, Pennsylvania.

During the holidays, the Harbins sell Christmas trees (from Pennsylvania) and homemade wreaths. Their stand is open seven days a week from April through December.

Dorothy Rest, Kimberly's mother, is in charge of Quality Control. The produce is sold by volume, not weight. "We're old fashioned," she says. Robert Harbin believes in the way things used to be. He does his accounting by hand and refuses to use a calculator or a cash register. He also believes that the most desirable place to live in Howard County is North of Route 40 and West of Route 29. This is where he lives, and this is where he wishes to be buried. He is well rooted!

The roots of "Open 7" are in Fauvism. Fauvism evolved in Paris in the early 1900s with Andre Derain, Maurice de Vlaminick and Henri Matisse, who believed in strong vibrant colors and the contrast of thick and thin paint.

It was important for me to paint a tactile and edible quality of the produce (depicted in bright and thick paint) against the backdrop of the barns and trees (depicted in dull and thin paint).

I will never forget the pride and joy the Harbins found in their fresh tomatoes, beans, fruit, and more.

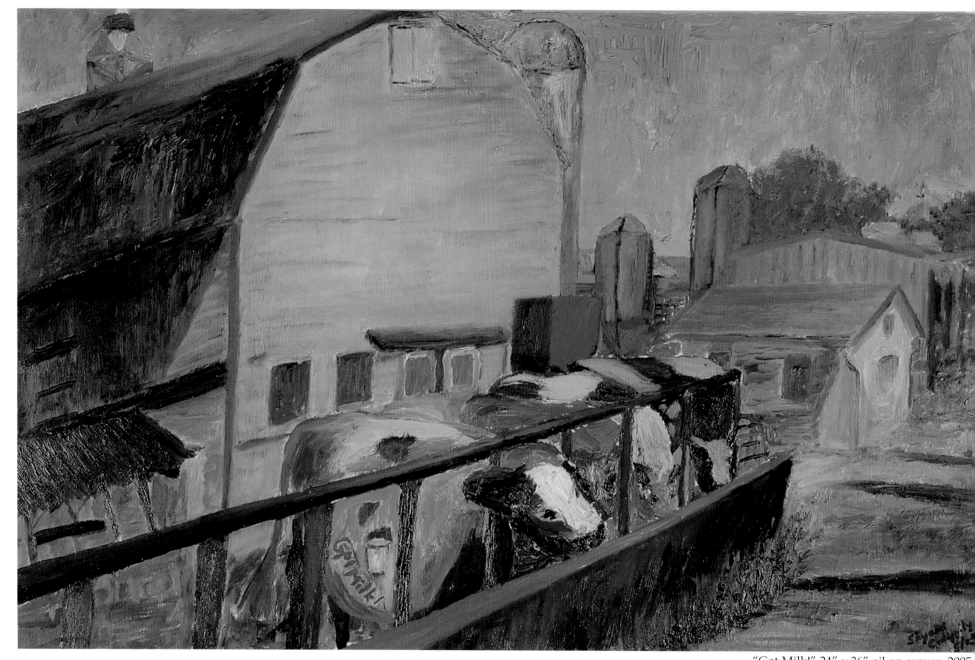

"Got Milk!" 24" x 36" oil on canvas, 2005

"Got Milk!"

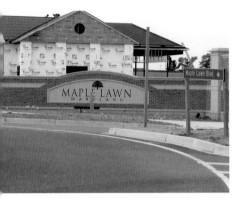

Maple Lawn Development
entrance, 2005

Maple Lawn Farm is located on Route 216, known as Scaggsville Road, just to the West of Route 29. The Iager family, who originally came from Germany, established this farm in 1839. The farm is operated now by the 4th, and 5th generation of Iagers, including cousins Will and Mark Iager. Charles and Gene Iager, the fathers of Will and Mark, are in charge of overseeing various aspects of their farm. This farm has always been a dairy farm. In recent decades, turkeys are being raised. The milk is sold to the MD-VA co-op, and the turkeys are sold to stores, restaurants, and the general public.

Maple Lawn produces 12,000 lbs of milk per day from its 165 cows. The milk truck comes every other morning to pick up the milk and take it to the co-op for processing. The milkers are automatic, and the milking parlor is arranged in a pattern known as "Double Nine Herringbones." The cows are milked twice a day, 365 days a year. The cows are fed a gourmet blend of corn, roasted soy beans, beet pulp, and citrus pulp. The turkeys are purchased when they are a day old from Canada, Michigan, and Ohio. They are housed in the buildings across from the dairy barns, and are prepared for sale around the Thanksgiving and Christmas holidays.

This particular farm was originally 500 acres. Two hundred acres are currently being developed into a residential and commercial community. The community will include various types of housing, stores, community center, gym, pool and more. This new community will have its own zip code and will be known as Maple Lawn, Maryland. Although the development of the intersection of Routes 216 and 29 has brought much traffic and other issues, Will has his heart set on staying in the farming business. Will hopes that the remaining 300 acres of this farm, combined with other farmland that the family owns nearby, will assure the continuation of their farming tradition for many years to come.

A will to hope and a will to continue is what keeps anyone's work thriving. As I painted "Got Milk!" I had a chance to reflect on the ever-changing world, psychology, and reality. Is art about capturing a replica, or is it an interpretation of reality? Some physicists believe that we live in an eleven-dimensional universe. If that were true, how could an artist capture so many dimensions on a two-dimensional surface? Is an interpretation tangible?

Calves on the Iager Farm, 2005

I will never forget the tangible cows feeding at the trough to produce milk for the next morning's milking.

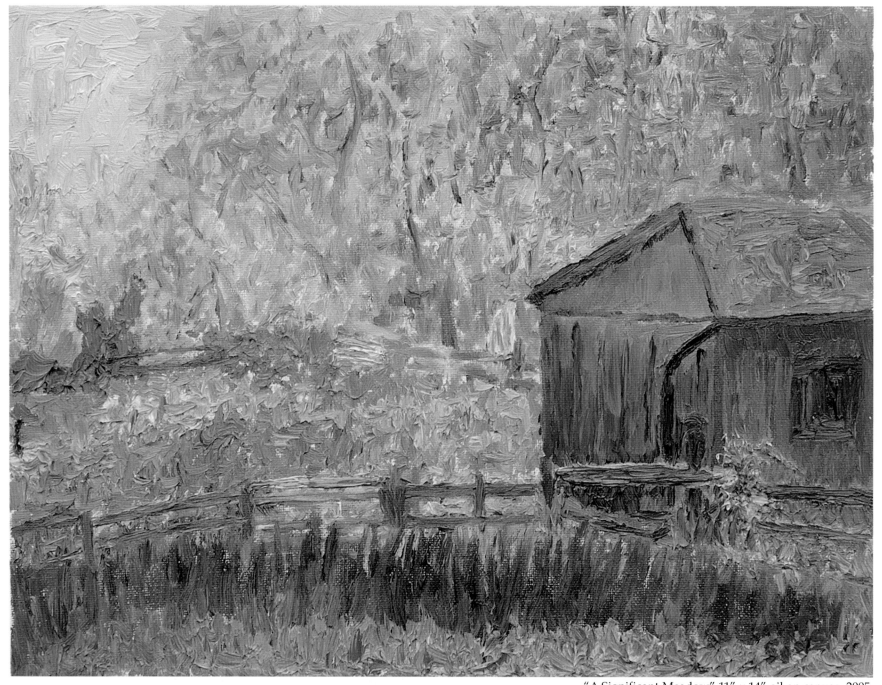

"A Significant Meadow" 11" x 14" oil on canvas, 2005

"A Significant Meadow" & "Dawn On The Bandel Farm"

A family named Cissel farmed in West Friendship
Their foundations are remains of their joy and hardship
They sold to Anderson, Twigg and Watkins whose lane
Was Rosemary that is now home to many a new name.

Rosemary Lane is located between Route 32 and Triadelphia Road. The property of one of my neighbors contains the Cissel Family's log cabin from the 1920s. Another family's, the Peklo's, home contains the foundation of an original hay barn. The Morrison family has remains of metal fencing, from that period, embedded in the trunk of a tree that was torn down by a hurricane. They have found more metal fencing in their woods along what was thought to be the pathway by which the cows were led to market. The old Cissel hay barn, later modernized by the Watkins family, housed one of the first mechanized milking systems in the area. Lore has it that the cows would run past their fence, down the hill of my front yard, and would have to be chased back up to their barns.

Much has happened since the 1920s. In the late 1980s a tornado struck, and on May 30th, 2005 a helicopter landed in my front yard to transport an injured neighbor to the hospital.

Dr. Allan Bandel grew up on the farm at the Southeastern end of Rosemary Lane. Later, he became a Professor of Agronomy at the University of Maryland, College Park. He spoke to me of the area's history. His parents, Vernon and Ina Bandel, owned a 110-acre farm, known as Veri-Aldon Farm, on Triadelphia Road until the 1970s, and also farmed about 350 adjacent rented acres. They raised chickens and dairy cows, and grew corn, wheat, barley, and alfalfa hay. Most of the original farm is now part of the county's future Benson Branch Park. About 10 acres remain in the family, equal portions owned by Bandel's daughter and his brother, Donald. An aerial view can be seen on the "Acknowledgements" page, and the farm today, "Dawn On The Bandel Farm," can be seen on the "Copyright" page of this book.

Paul and Stephanie Olson, who have lived in the neighborhood since 1972, remember why they moved to this part of the county. "We wanted to live a rural life of hard work, perseverance, sacrifice, faith in God, love of country, and helping our neighbors - values on which our country was founded." They saw their family as the "intermediary between the real farmers and what this area has been in the process of becoming over more recent years."

When the Olson's children were young they raised sheep and pigs as 4-H projects. The children rode through snow on horse-back to deliver Christmas presents to the few neighbors on Rosemary Lane. Those horses used to graze on the adjoining field, as seen in "A Significant Meadow."

Depicting significant details is a skill of an artist who paints more than just the "Pretty Picture." To the left edge of this landscape, there is a small significant red flag in the meadow, just beyond the Olson's fences, where a "perk test" has been performed.

I will never forget that my yard has seen significant activity: running cows, a tornado, and a helicopter.

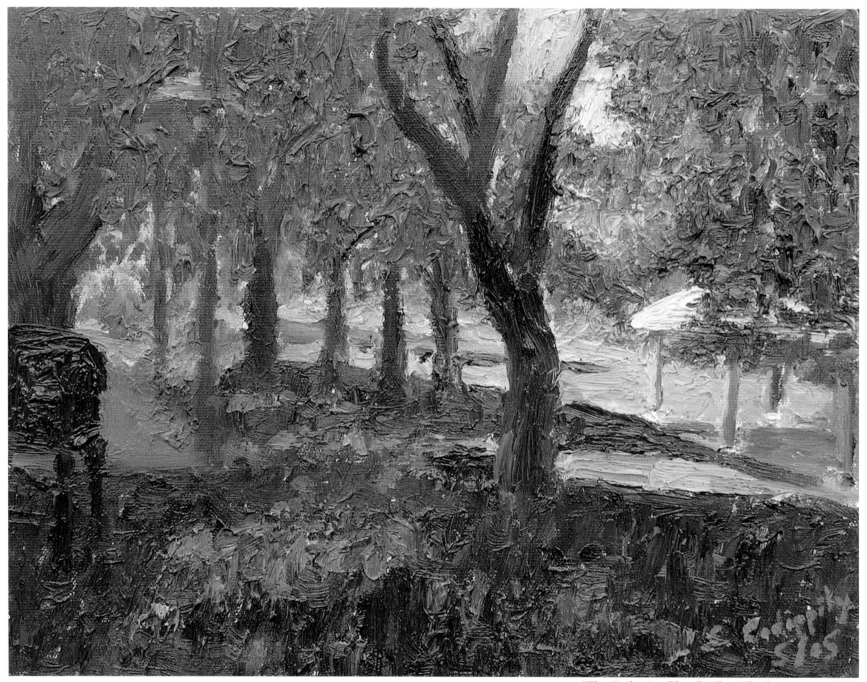

"The Gathering Place" 11" x 14" oil on canvas, 2005

66

"The Gathering Place"

Bridal arch and gazebo on
Nixon's Farm, 2005

Randy Nixon resides on 128 acres of prime Route 32 land in West Friendship, and is in no hurry to sell his land to developers. If he did decide to sell, he, his mother, and brother could retire today with 16 million dollars and change in their pockets. For now, he is content to operate his catering business, and host weddings as well as corporate and holiday social events.

Randy Nixon earned undergraduate degrees in History and Philosophy at Cornell University, a Law degree at Indiana University, and a Masters in Philosophy at Johns Hopkins University. After spending time in the corporate law field, he returned to his father's field, which was known as Glenwood Country Club in the 1970s.

In 1956, Mr. Nixon, Sr. purchased this farm from Mr. Arrington as a land contract. The farm was originally 163 acres, but 35 acres of it was purchased by eminent domain by the county. Randy remembers when the county first proposed plans to expand Route 32, back in the 1960s. Then, Route 32 was designed to serve as a major link to Baltimore and Annapolis.

Today, Route 32 is a source of heated debate among residents due to traffic and construction issues.

Randy used to grow crops on his farm, but the traffic on Route 32 made it difficult to operate his equipment. In 1988 Randy decided to develop a new business. He now uses his 128 acres as an ideal venue for catered weddings, company picnics, and murder-mystery weekends. Someday, he would like to see the property turned into a country club with an upscale restaurant, where people could gather and celebrate from light until dark.

"The Gathering Place" emphasizes the contrast between light and dark. In the shadows on the left, there is a barbecue grill and a grilling area, in contrast to the sun-drenched vistas and a party-tent on the right. The intensity of the light yellow and green in the background are made possible by the dark purples and reds in the foreground. In color theory, if you desire one color to be intensified, that color's opposite has to be surrounding it in some form. The same could be said of culinary theory - to highlight something sweet, a chef would need to contrast it with something pungent.

New homes adjoining Nixon's
Farm on Route 32, 2005

I will never forget the culinary aromas emanating from Nixon's kitchen as I painted his luscious landscape.

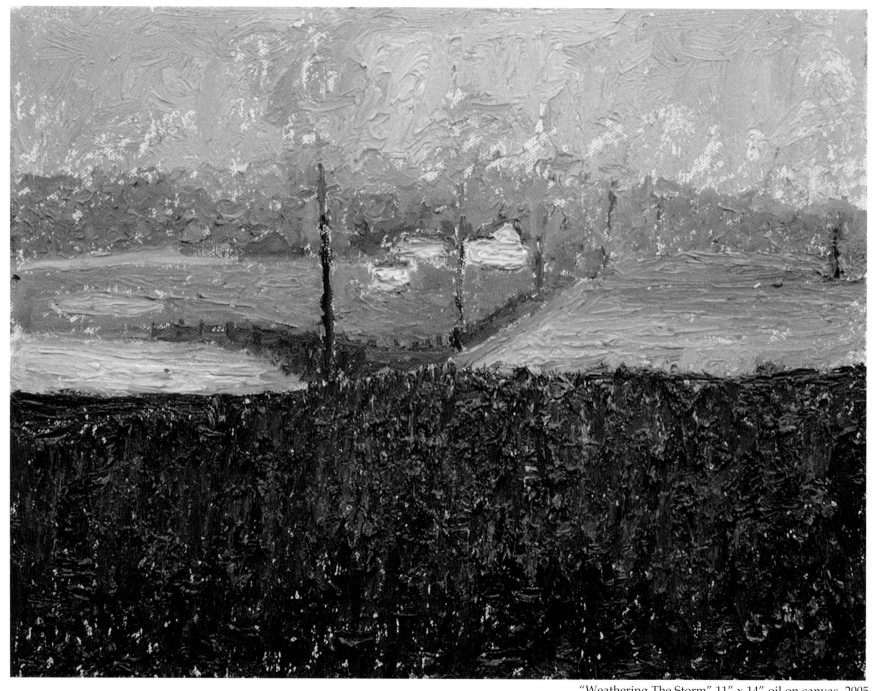

"Weathering The Storm" 11" x 14" oil on canvas, 2005

68

"Weathering The Storm"

> *Battling gusting wind and heavy rain*
> *Atop Breezy Willow's lush terrain*
> *I could touch the Caulder's plants of soy*
> *And see many a farmer's pride and joy.*

There is an expectation that by the third week of May the weather will be warm and sunny, and great for outdoor recreation. This year's Spring had been unusually cool, and I picked the most blustery wet day to visit Breezy Willow Farm on Old Frederick Road in West Friendship.

In contrast to the day, I experienced warm hospitality and a cozy home when I visited R.J. Caulder. The Caulders have lived on Breezy Willow Farm for twenty-one years. The Caulders raised dairy goats as 4-H projects for their children.

After her children were grown, R.J. went into business manufacturing goat's milk soap and other natural body products. She now purchases her goat's milk from Martha Clark (owner of Clark's Elioak Farm), and uses a "Cold Process" to make her soaps. She also incorporates her home grown herbs (such as chamomile and lavender) into her traditional recipes. In addition to the herbs, she grows a variety of vegetables, berries, and flowers. She started her own Community Supported Agriculture (CSA), where for $30.00 a week she delivers an assortment of fresh veggies, dairy products and baked goods to her customers' homes. Her dairy and other goods come from nearby farms, and the business thrives on her meticulous attention to detail.

Across the road from Breezy Willow is the Rhine Farm, established by the late John Rhine, Sr. in 1923. Until about a year ago, the Rhines operated a dairy business. In recent years, John Rhine, Jr. has cultivated a landscaping business on the farm. Since there is a growing population in Western Howard County, the Rhines believe that their landscaping business will continue to thrive.

Continuing to thrive is what "Weathering The Storm" signifies. The wet, blustery day did not dampen my desire to paint. Although the rain soaked my canvas, paints, and clothes, I was still warm inside - for I could see for miles what makes a farmer thrive - green and gold fields, saturated ponds, and a big sky, whether blue or gray!

I will never forget weathering Breezy Willow's gusting storm - a challenge for a farmer and a painter.

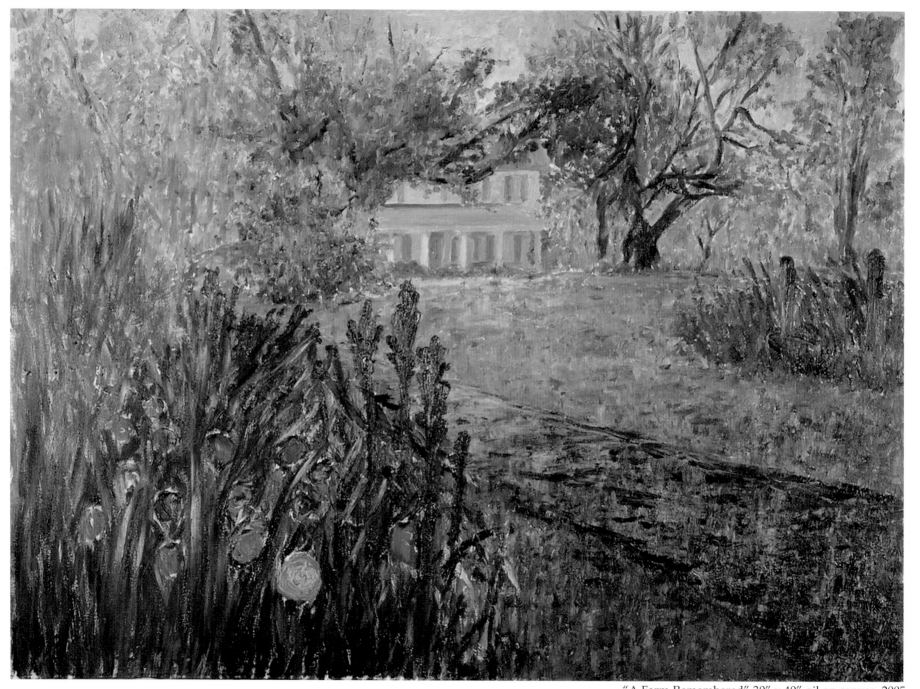

"A Farm Remembered" 30" x 40" oil on canvas, 2005

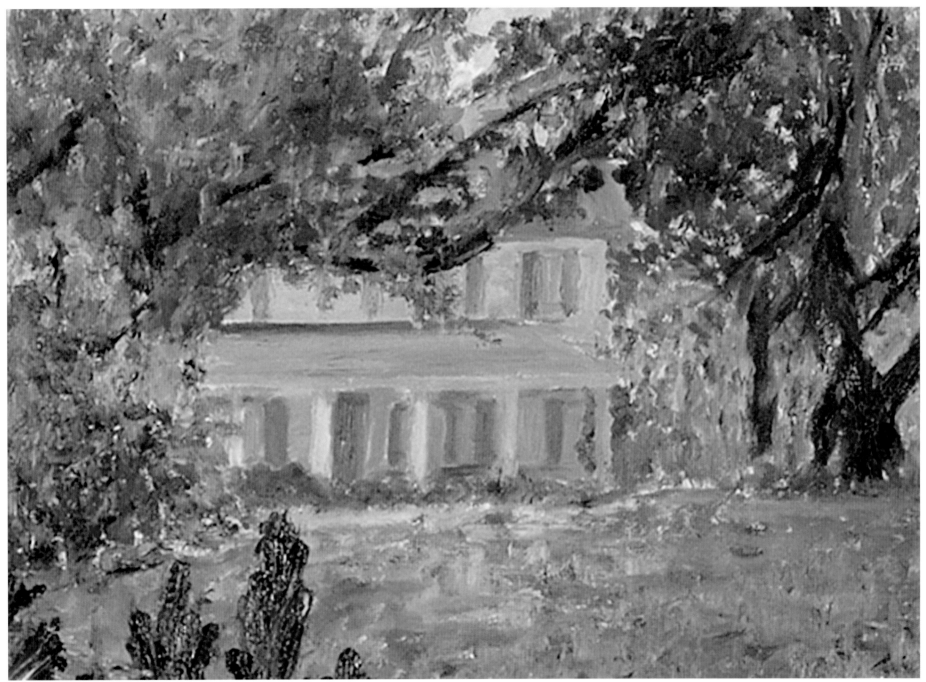

"A Farm Remembered" detail

"A Farm Remembered"

1927 Case Tractor
Photo: John Frank

Now that I have journeyed through Western Howard County, I am truly amazed at how, in the spirit of John Locke, the farmers have made the best use of their land. I am awed by the ingenious methods with which the farmers have met their challenges over time. The various grain farms, horse farms, vegetable farms, sod and landscaping farms and agri-tourist farms are all examples of Western Howard County's current pastoral landscape. As my artistic journey through Western Howard County's farms comes to a close, I am only now beginning my journey into the past. What I seem to have done so far is merely scratch the surface of the stories behind the ears of corn, flocks of sheep, and herds of steers.

Future historical journeys into Howard County's rich, deep past will be accomplished through the new Howard County Farm Heritage Museum. Construction is proposed to begin the Summer of 2005, and the first phase will take about five years to complete. The museum will include many display areas and interactive sites. The proposed site for the museum is located across from the Howard County Fairgrounds, on what is known as the Hebb Farm, located at 12985 Frederick Road (Historic National Pike) in West Friendship, MD. The Farm Heritage Museum will include the farmhouse that belonged to the Hebb Family, originally owned by the Gaither Family in the early to mid 1800s. In 1871 Dr. John Wise Hebb married Sarah Gaither, daughter of Washington Gaither, the farm owner, and took over farming operations.

The farm is currently owned by the Howard County Department of Recreation and Parks and leased by the Howard County Antique Farm Machinery Club. The Howard County Antique Farm Machinery Club is a non-profit group established in 1995. The members of this club are currently working with Howard County's Department of Recreation and Parks to develop a living Farm Heritage Museum on about 39 acres at the Hebb Farm in West Friendship Park.

According to John Frank, the President of the Antique Farm Machinery Club, the goal of the museum will be to focus on all aspects of historical agricultural life spanning a timeline from Native American life (1500s) prior to early European settlers through the close of the 20th century.

Howell's Sheep
Photo: Peggy Howell, 2004

The purpose of the museum will be to provide an educational setting for visitors while incorporating a hands-on, interactive experience through many of the displays. The museum will focus on contributions made by various cultural groups, as well as practices and equipment relating to farm life throughout the timeline.

The Museum will host a number of site displays, including a Native American camp, 1700s homestead farm, 19th and 20th century homesteads, a saw mill, a grist mill, and a blacksmith shop. Each year, field displays will include crops such as corn, wheat, and hay. Visitors will be able to view each phase of crop development throughout the growing seasons.

Other activities provided at the museum will include educational lectures, wildlife presentations, school-related activities, senior citizen activities, music concerts, and Recreation and Parks programs.

The Howard County Antique Farm Machinery Club has high expectations for the Museum and is happy to be able to preserve the history of the Hebb Farm as well as other aspects of Howard County's agricultural history.

A visit to the Howard County Farm Heritage Museum will be like a walk through time. Since this is proposed to be one of the premiere facilities in the region, visitors of all ages will experience a family-oriented atmosphere.

"An atmosphere that encompasses art through the ages," might be what an art critic would say about "A Farm Remembered." The painting's depiction of paths and objects that lead the eye to a focal point, the farmhouse, are in tune with Da Vinci's Perspective theory. The voluptuous, entwining trees and shrubbery embraces Michelangelo's Pathos theory. The distant haze brings out the Atmospheric conditions of the Impressionists Claude Monet and Van Gogh. The Bright colors are reminiscent of the Fauve painters Vlaminic and Derrain. The movement of the tall foreground grass and flowers encompass Duchamp's Movement theory. I myself would simply say that I was out on a bright sunny day painting what I saw with all my heart and soul.

This old farmhouse will soon be alive again. For me, this painting has particular significance. In this house there lived a farmer and his family, who worked their land, with all their hearts and souls. It is only fitting that a museum will be established to preserve the memories of this way of life!

I will never forget the home-site of the Farm Museum, a place where the farmers would never be forgotten!

Sources of Information & Inspiration

PAGE 11 Second Treatise of Government by John Locke; Stanford Encyclopedia of Philosophy webpage www.plato.stanford.edu.
 United States budget web page www.us.gov.budget.
 2002 Census of Agriculture - County Data; County Summary Highlights for 1992, 2002.
 2002 USDA Census of Agriculture & Howard County by Ginger Myers, Howard County Economic Development Authority.
 Howard County Grown - Economic Profile, Howard County Economic Development Authority.
 Article on Clarksville Facility History: Central Maryland Research & Education Center, Ellicott City, MD.
PAGE 13 University of MD College of Agriculture & Natural Resources; Caragh Fitzgerald, Ellen Nibali - MD Cooperative Extension.
PAGE 15 History of Merry Acres Farm - Verbal Narratives by Howie Feaga, and Dr. Allan Bandel, Professor Emeritus, University of Maryland.
PAGE 17 History and Information by Father Donald, Interim Director: Shrine of St. Anthony, Folly Quarter Road, Ellicott City, MD.
 Article on Clarksville Facility History: Central Maryland Research & Education Center, Ellicott City, MD, and Dr. Allan Bandel.
PAGE 19 History of Dawn Acres Farm - Verbal narrative by Mr. and Mrs. Moxley.
PAGE 22, 23 Looking West by Howard County Government TV; excerpts from A Pictorial History of Howard County by Joetta Cramm.
 History of Smith Farm - Verbal narrative by Gerald Cooney.
PAGE 25, 27, 29, 31 History of Clarkland Farm and Clark's Elioak Farm- Verbal narratives by Senator James Clark and Martha Clark.
 Isaac Newton by James Gleick, Vintage Books, June 2004
PAGE 33 Dr. Allan Bandel, Professor Emeritus, University of Maryland; Ms. Sharon Russell, Univ. of MD, CMREC.
PAGE 35 Looking West by Howard County Government TV; Excerpts narrated by Sharon Sams, video taped by Greg Wright.
 History of Roberts Inn Farm - Verbal Narrative by Mrs. Bell; The Fabric of The Cosmos by Brian Greene; A. Knopf, 2004.
PAGE 37 History of Trouble For Nothing Farm - Verbal Narrative by Mrs. Sue Harrison.
PAGE 39 History of Mullinix Farm (Florence) - Verbal Narratives by Mrs. Kathryn Mullinix, Jesse and Emily Thoresen.
PAGE 41 History of Trail Farm- Verbal Narrative by Mr. James Ferguson.
PAGE 43 Dr. Hilarian Codippily, Sr. Economist/Consultant World Bank; Dr. Kaoru Nabeshima, Economist, World Bank;
 Howard County Grown - Economic Profile, Howard County Economic Development Authority.
PAGE 45 History of Mullinix Farm - Verbal Narrative by Mr. Mullinix.
PAGE 47 History of Patrick Farm - Verbal Narrative by Mr. David Patrick.
PAGE 49 History of Clevenger Farm - Verbal Narrative by Mrs. Clevenger; Excerpts from Mr. Bill Brendel; A Pictorial History of HC by J. Cramm.
PAGE 51, 54, 55 History of Mt. Pleasant- Howard County Conservancy website: www.mtpleasant.org; Lynne Nemeth, Executive Director.
PAGE 57 History of Marriottsville Ridge - Verbal Narrative by Mr. Ron Stevenson; Excerpts from Mr. Jay Harrison.
PAGE 59 History of Stillridge Farm - Verbal Narrative by Mrs. Mary Lou Riddle.
PAGE 61 History of Harbin Farm - Verbal Narratives by Kimberly Taylor, Robert Harbin, and Dorothy Rest.
PAGE 63 History of Maple Lawn Farm - Verbal Narrative by Will Iager.
PAGE 65 History of Rosemary Lane - Verbal Narratives by Dr. Allan Bandel, Drs. Brian & Haydee Morrison, Mrs. Stephanie Olson, Mrs. Lisa
 Peklo; West Friendship by 1983 4th grade West Friendship class & Ellen Nibali; and Gail Bates, Republican Delegate.
PAGE 67 History of Nixon's Farm - Verbal Narrative by Mr. Randy Nixon.
PAGE 69 History of Breezy Willow Farm - Verbal Narrative by R.J. Caulder; Excerpts from Mr. J. Rhine.
PAGE 72, 73 History of Hebb Farm and plans for upcoming Museum - Written Statement by John and Virginia Frank.
WORKS OF ART Various artists and their works as interpreted by the author by viewing originals and absorbing information from books - History of Art
 by H.W. Janson; Prentice Hall, Inc., NJ & Modern Art by Hunter and Jacobus; Prentice Hall, Inc. NJ.

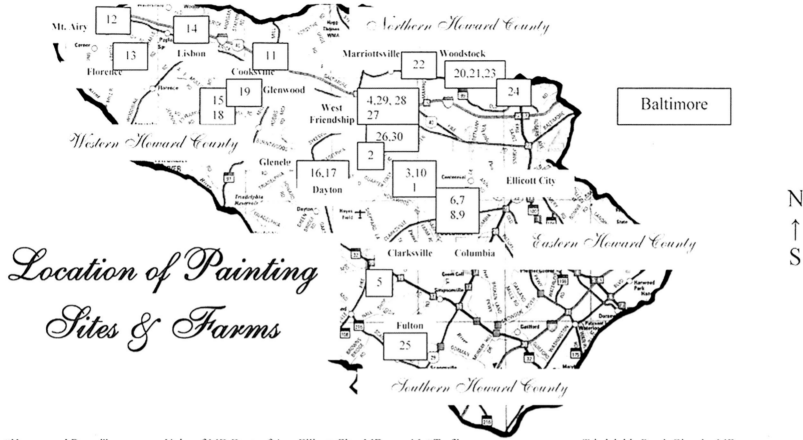

Location of Painting Sites & Farms

Baltimore

Washington, D.C.

N ↑ ↓ S

1. "Homewood Bound" Univ. of MD Dept. of Ag., Ellicott City, MD
2. "Intense Feaga" Merry Acres Farm, Ellicott City, MD
3. "Folly Quarter Jewel" Univ. of MD Dept. of Ag., Ellicott City, MD
4. "Dawn Acres Fenced" Dawn Acres Farm, West Friendship, MD
5. "Clarksville Splendor" Smith Farm, Clarksville, MD
6. "One Way To Silver Queen" Clarkland Farm, Ellicott City, MD
7. "Sunflowers At Sunrise" Clarkland Farm, Ellicott City, MD
8. "Pathway To Silver Queen" Clark's Elioak Farm, Ellicott City, MD
9. "Sheep Down Yonder" Clarkland Farm, Ellicott City, MD
10. "Homewood Storm" Univ. of MD Dept. of Ag., Ellicott City, MD
11. "Integration By Arts" Robert's Inn Farm, Cooksville, MD
12. "Trouble For Nothing" Trouble For Nothing Farm, Mt. Airy, MD
13. "Time-Travel ...Florence" Mullinix Farm, Florence, MD
14. "Penetrating The Fog" Trail Farm, Lisbon, MD
15. "A Deep Cold Winter" A small family farm, Daisy, MD
16. "Turf" Triadelphia Road, Glenelg, MD
17. "Lurking Cattle" J. D. Mullinix & Sons farm, Glenelg, MD
18. "Flipping Calves" Maple Dell Farm, Daisy, MD
19. "Regenerating Life" Clevenger Farm, Glenwood, MD
20. "The Feathery Front" Ho.Co. Conserv. Mt. Pleasant, Woodstock, MD
21. "The Song Of The Stream" Ho.Co. Conserv. Mt. Pleasant, Woodstock, MD
22. "Heaven On Earth" Marriottsville Ridge, Marriottsville, MD
23. "Wade Among The Herbs" Stillridge Farm, Woodstock, MD
24. "Open 7" Harbin Farm, Ellicott City, MD
25. "Got Milk!" Maple Lawn Farm, Fulton, MD
26. "A Significant Meadow" Fox Run Farm, West Friendship, MD
27. "The Gathering Place" Nixon's Farm, West Friendship, MD
28. "Weathering The Storm" Breezy Willow Farm, West Friendship, MD
29. "A Farm Remembered" H.C. Dept. of Rec. & Parks, West Friendship, MD
30. "Dawn On The Bandel Farm" Bandel Farm, Ellicott City, MD

Farms Never To Be Forgotten

by

Shyami Codippily

A beautiful presentation of
Western Howard County's Landscape
through Art and Prose.

Congratulations and Best Wishes

Dr. Hilarian and Mrs. Sheila Codippily

78

Saying Goodbye to a Way of Life

[text partially obscured]

expand Maple Lawn's commercial space by 685,000 square feet and add 466 new houses and 52 apartment units. It would also require a new road to be built connecting the additional residential and commercial areas.

Existing plans allow for 485 single-family houses, 395 townhouses and 236 apartment units to be built in addition to retail and office complexes.

Resident Stuart Kohn asked: "When is enough enough?"

Kohn upbraided the Department of Planning and Zoning for approving the request with 10 unanswered questions. "DPZ took the least course of resistance," he charged. He wondered how development projects continue to be approved when County Executive James Robey said the county's infrastructure is in dire need of repair and upgrading, a move that will cost millions.

Greg Brown
Business Monthly
May 2005

> "Route 29 south backs up for three miles now. How will (Route) 216 handle this additional traffic."
>
> Greg Brown
> Cherrytree Farms

County Gets Conditional Ag Preservation

JACQUELINE E. BURRELL

Maryland's Agricultural Preservation Foundation recertification of Howard agricultural preservation program month, but only if the county is a certain conditions – namely slow growth of residential density in th...

Maple Lawn Farms Hearing

JACQUELINE BURRELL

A deal is a deal, Fulton area residents told the Planning Board Monday night. They are concerned over a new request by Maple Lawn Farm's developer to add more housing and commercial density to the 500-acre mixed use subdivision.

With the acquisition of Greenwood Associates, ... units ...backs up for three miles now. How will (Rt.) 216 handle this additional traffic. ... Commuter buses use both lanes to turn around the traffic circles small radius.

Only three things have changed since the original decision and order five years ago, said Brown. "The roads are more crowded. The schools are more crowded. And the developer bought more land."

When plans for Maple Lawn were first approved, the number of houses was limited to 2.2 an acre. Land acquired later was restricted to 2.3 houses per acre. The new proposal would up that limit to 2.7 houses per acre, based on the additional acreage and number of units.

Perry W. Alexion ...
Greater ...

Pictured (l-r): Guy Guzzone (Howard County C... Citizen Services), Phyllis Madachy (Office on ... Robey (County Executive), Jean Roesser (M'... ...d County ...rk & Recs).

Breaking Ground

Construction to Begin on West County Community Center

TAMMI SLATER

In 1994, Al... House, which form... ly housed the West... Howard Ser... Center, was purchased... the county. Now the prop... ty is about to undergo an... er transformation, one... leaves young and old a... anticipating its completi...

The Glenwood Commun... at Western Regio... ...ated off Route... ...house what ma... ...re to be "the se... ...ter of the future."

Wednesday, March... marked the official gro... breaking ceremony for... center, led by How... County Executive J... Robey and the How... County Departments... Citizen Services - the Off... on Aging and Recrea... and Parks.

Farm Museum is Linked to Preservation of a Lifestyle

TAMMI SLATER

Howard County residents will soon be able to travel through time in a living farm heritage museum.

The Howard County Antique Farm Machinery Club, Inc., a non-profit organization, is to receive 39 acres of parkland located in West Friendship. The club... approval of the County Council, pending... would lease the property for five years at... $900 a month, with four optional five-year... renewals possible.

The location, once the proposed site of a... second golf course in the county years ago,... has now become the focus of agriculture... preservation among farmers and residents in... the rural west. On Mon., June 20, approxi... mately 40 citizens filled the Banecker Room... for a public hearing before the County... Council on Council Resolution No. 84-2005.

"Our county was based on agriculture... preservation, and we can minimize the... ongoing loss of agricultural preservation by... getting a farm museum as soon as possible,"... said Ellicott City resident John Frank,... President of the Howard County Antique... Farm Machinery Club.

(continued on page 4)

Randy Nixon Had a Farm – And He Still Does

[article text largely illegible]

...dy Nixon has a farm...
...nd on this farm, he has a barn...

...nd on this farm, for the last 10 years or... ...have been company picnics and din... ...weddings, retreats, theme parties and...

...t on this farm off busy Route 32 in... Friendship, at some point in the not-... distant future, there might sprout a... ...dozen $600,000 homes.

...but that development is not now, and... ...wants to get the word out that "we're... ...for business and for the conceivable... ...e we will be."

on the parcel recently.

For years, he said, he's been pestered by developers as land in once rural Howard County got gobbled up at higher and higher prices.

"If you're not proactive, then you get blind-sided. ... Landowners have to educate themselves," Nixon said. "Everybody sees the value in the land."

He said he "created a bid package last year" that went out to developers. "We wanted to see what the marketplace would bear."

"It's a very valuable piece of property," said Chip Lundy, president and CEO of the Williamsburg Group, a longtime Howard County homebuilder which put up the Fox...

Reprinted with permission from The Business Monthly

Youth AgBusine...

The Agriculture Committee of the Howard County Economic Development Authority awarded the 2005 "Howard County Grown" Youth ... Business Development Grant...

Grant Awarded

ABOUT THE AUTHOR

Shyami is an Internationally recognized artist living and working in West Friendship, MD. She is known by her married name "Shyami Murphy" to family and friends, but uses her maiden name "Codippily" when signing her artwork. She studied Drawing and Painting under Walter Bartman at Walt Whitman High School, Bethesda, Maryland, for many years. From 1985-1986 she attended Carnegie-Mellon University in Pittsburgh, PA, on a full scholarship. From 1986-1989, she attended The University of Maryland, College Park, MD, to complete her Bachelor of Arts degree, with a major in Fine Arts, and a minor in Art History. In her most recent careers, she has worked for Howard County's Tourism Council, Department of Recreation and Parks, and Department of Citizen Services. She lives on a fraction of what used to be the Cissel Farm with her husband Scott, son Taylor and Golden Retriever, Polo.

Shyami was born in Colombo, Sri Lanka. She has been an artist since the age of three- when she splattered blue paint all over herself. She won the UNICEF International Art Award in 1979, and was honored as one of the Top Twenty Artists in the U.S. in 1985 by the National Foundation For the Arts. Her most recent participation was at the World Bank, Washington, D.C. in their 2005 juried exhibition entitled "Landscapes of Expression." Aside from painting landscapes in oil, she also sculpts in marble, and produces much for her gallery shows and commissions. Her work can be viewed on www.shyami.com. The "Farms Never To Be Forgotten" collection and other collections are being exhibited in various locations in the United States and abroad.